THE
DROWNED
BOOK

THE DROWNED BOOK

ECSTATIC AND EARTHY REFLECTIONS OF BAHAUDDIN, THE FATHER OF RUMI

Translated by

COLEMAN BARKS *and* JOHN MOYNE

HarperSanFrancisco
A Division of HarperCollins*Publishers*

HarperCollins books may be purchased for educational, business, or sales promotional use. For information please write: Special Markets Department, HarperCollins Publishers, Inc., 10 East 53rd Street, New York, NY 10022.

Blue Tongue and *Heal All* endpaper illustrations by Sam Seawright, copyright © 2004. Water color on paper.

HarperCollins Web site: http://www.harpercollins.com
HarperCollins®, ♣®, and HarperSanFrancisco™ are
trademarks of HarperCollins Publishers, Inc.

FIRST EDITION
Designed by Joseph Rutt

Library of Congress Cataloging-in-Publication Data
Baha' al-Din Valad, 1150–1231.
[Ma'arif. English. Selections]
The drowned book : ecstatic and earthy reflections of Bahauddin,
the father of Rumi / Coleman Barks and John Moyne.
p. cm.
Includes bibliographical references.
ISBN 0–06–059194–3 (cloth)
1. Mysticism—Islam—Early works to 1800. 2. Sufism—Early works to 1800.
3. Islamic sermons, Persian. I. Barks, Coleman. II. Moyne, John. III. Title.
BP189.B28213 2004
297.4—dc22 2003067557

04 05 06 07 08 ❖ RRD(H) 10 9 8 7 6 5 4 3 2 1

for fathers, for aging,
and the freedom of knowing nothing

CONTENTS

[1]There are no titles for the entries in Bahauddin's *Maarif*. We have added these for reference.

BOOK TWO

BAHAUDDIN'S *MAARIF*

This book introduces readers to a document known as the *Maarif*,[2] written by Bahauddin Valad (1152–1231), father of the mystic poet Rumi. The *Maarif* is a collection of visionary insights, questions and responses, conversations with God, commentary on passages from the Qur'an, stories, bits of poetry, sudden revelations, medicinal advice, gardening hints, dream records, jokes, erotic episodes, and speculation of many kinds. A mystical compost heap, may it thrive and nourish readers.

Other than Shams Tabriz, Rumi's fiery friend, perhaps no one had more influence in shaping his awareness than his father. One of several legends about the meeting of Rumi and Shams involves this book, the *Maarif*. Rumi is sitting by a fountain in Konya talking to students. Bahauddin's notebook is open on the fountain ledge. Shams interrupts and pushes that precious text and others into the water.

"Why are you doing this?" asks Rumi, protesting that this copy of his father's diary is the only one extant.

"It is time for you to live what you have been reading of and talking about. But if you want, we can retrieve the books.

[2]*Maarif* may be used here in the generic sense of "teachings" or "ideas," or it may carry esoteric significance, as we suggest later. The text has the feel of notes taken on retreat, with its abrupt stops and starts. There is not the flow of a discourse or the chatty dailiness of a journal. The eminent Rumi scholar Annemarie Schimmel, who taught at Harvard University, where John Moyne studied with her, and at the University of Bonn, calls it "diarylike." Schimmel died recently. Sufis love retreats, the replenishment of going into silence and being away from society. Bahauddin's questionings and assertions have the flavor of having flowered out of a practice. Franklin Lewis says it is not unusual for a Sufi master of this period to keep a private record of his internal life, with no intention to make it available as a book.

They'll be perfectly dry. See?" He lifts Bahauddin's book out, "Dry."

So there's a powerful intersection of Shams and Bahauddin in Rumi's transformation, though they never actually knew each other. Bahauddin dies (1231) before Shams and Rumi meet (1244). Both are passionate, daringly original mystics. They talk intimately and sensually of Friendship with the divine. Neither is a poet, but Bahauddin carves out what Annemarie Schimmel calls "great glowing, awe-inspiring boulders of Persian prose, passages whose bizarre sensual imagery express his intense love of God," and Shams drives a fierce, confronting, jocular back-and-forth through his discourses.[3] They both passionately long for more intimate and essential motion within the presence.

Rumi tells an incident in Discourse #10 about a government official coming to visit his father. Bahauddin tells the man he shouldn't have gone to such trouble.

"I am subject to various states. In one state I can speak and in another I do not speak. In another I can listen to the stories of other lives and respond to them. In yet another I withdraw to my room and see no one. In a further absorption in God, I am utterly distraught, unable to communicate. It's too risky for you to come here on the chance I might be amiable enough to have conversation."

Bahauddin lives in his outrageously imperial soul. Degrees of surrender wash over him like weather. He has no *personal* control as to when he might be available to give counsel or respond to friends, being always on retreat with his wild inner life. That powerful spontaneity might turn out to be

[3]See William Chittick's new translation of the *Maqalat,* titled *Rumi and Me: The Autobiography of Shemsi Tabriz* (Louisville, KY: Fons Vitae Press), 2004.

more than a visitor could endure. One feels the relentless pressure of honesty in these entries. Whatever else he is, Bahauddin is authentically himself.

A similar incident. One day Bahauddin's students find him in a state of rapture. They have come to join him for evening prayers. He pays no attention to them but stays in his silent ecstasy. Two disciples sit down beside him, hoping to enter the blessed state. The others turn toward Mecca and begin praying with the Imam. Khavjegi is one of the latter group, but during the praying his inward eye opens, and he sees that those who had physically turned their backs on Bahauddin to face Mecca had in reality turned away from the light of God, while those who sat down with Bahauddin in his *samadhi* were showing how they truly wanted to be consumed in light as he was, following the divine command to *die before you die*.

Bahauddin was born about 1152 and died in Konya in 1231. His father, Jalaluddin Hosayn, died when Bahauddin was two. Family tradition says that his mother took the young boy by the hand into the library, which had come down from Hosayn's father, Ahmed al-Khatibi. "It was for these works that I was given in marriage to your father. Through reading these works your father gained the spiritual knowledge that gave him such a place of honor in the Islamic world." Books were a powerful field of growth in this lineage, and it was very significant to the family that the spark of mystical awareness had been lit by a woman. Through that beginning Bahauddin came to be known as the "King of Learned Men, Sultan of Mystical Knowing."[4]

[4]There is a story that many saints and scholars in Balkh had the same dream on the same night: that a radiant being had given Bahauddin the title Sultan ul-Ulema (see entry 1:188–189). Rumi's oldest son, Sultan Valad, was named for his grandfather.

At the time of Rumi's birth in 1207 Bahauddin was engaged in a powerful debate in Balkh, a controversy that had been raging for a hundred years at least. Simply put, it was the argument between mystics and philosophers, between those who rely on spiritual experience and those who accept and follow a received doctrinal coherence.

Ghazzali (d. 1111) began the debate with his attacks on Greek-based, rational philosophy. Bahauddin was a student of Ghazzali's work. The philosopher Fakhruddin Razi was his grand antagonist. Both were friends of the king. Razi accused Bahauddin of wanting to appropriate some of the king's power. The story is that the king sent Bahauddin the keys to his treasury and his crown. Bahauddin responded that he was not interested in any material realm of power and that he would gladly leave the country to dispel any rumor about his intentions. Probably it was at this time, in 1212 when Rumi was five, that Bahauddin took his family into voluntary exile in Samarcand. They returned to Balkh later, and in 1219 they began the journey that took them through Nishapur, Baghdad, Mecca, Damascus, Laranda, and finally to Konya. Before they left Balkh, Bahauddin gave a sermon before the king and a large assembly in which he predicted the destruction of Balkh by Mongol armies and the abolition of the monarchy, all of which happened in the next year, 1220 CE.

Allaudin Kayqubad, the enlightened Seljuk ruler of the region known as Rum, invited Bahauddin to Konya, where a school was built for him. After only two years as the spiritual head of the Konya community, Bahauddin died, at nearly eighty. His son Jalaluddin was appointed to the position by the sultan. Rumi was twenty-four.

Rumi's copy of the *Maarif,* the original drowned book, has never been found. The Furuzanfar edition in Persian of the

Maarif, from which we work, is in two volumes, nine hundred and fourteen pages total, so the collection we present here can give only a representative glimpse of the vast document that Rumi loved. He seems to have pored over it enough to have it by heart. A story is told of him reciting his father's *Maarif* without the text before him over an entire night, while one student took dictation and another dried the ink on pages in front of a fire. The great scholar Henri Corbin says, "The venerable sheikh Bahauddin's ample collection of mystic sermons, the *Maarif,* cannot be disregarded if we wish to understand his son's spiritual doctrine." We can assume that his father's book was Rumi's constant companion from Bahauddin's death until Rumi met Shams, a period of about thirteen years. Shams insisted, several times, that Rumi give up his dependence on Bahauddin's words, even to the point of not *dreaming* about reading them. Shams was able to enter Rumi's dream-state.

The *Maarif* was an extremely rare text in the thirteenth century, existing only in a very few copies and in Rumi's memory. Never published for general reading, the *Maarif* circulated, if at all, as a personal document. Between then and now the *Maarif* manuscripts were not "lost," as the Dead Sea scrolls were, away from *anybody's* knowing, but they certainly remained unnoticed on their library shelves for a number of centuries. An out-of-print German translation exists,[5] but it is not widely known, and A. J. Arberry included twenty entries from the *Maarif* in his *Aspects of Islamic Civilization as Depicted in the Original Texts.*[6]

[5] Fritz Meier, *Baha'-I Walad: Grundzüge Seines Lebens und Seiner Mystik* (Leiden: E. J. Brill, 1989).
[6] A. J. Arberry, *Aspects of Islamic Civilization as Depicted in the Original Texts* (New York: A. S. Barnes, 1964), pp. 227–255.

It is possible that some of the notebook jottings were meant to be only reminders to Bahauddin himself, topics he would elaborate on in later discourses, gardening reminders, various remedies. He would not have expected anyone to read those parts. Other entries have a definite feeling of prophetic transmission, reminiscent of the beautiful last sections of the Qur'an, short bursts of revelation on particular images or processes: afternoon, dawn, fig, blood-clot, night-star, forenoon. Those are sura titles from the Qur'an; from the *Maarif* the topics might be: vegetative renewal, digestion, and the core of desire inside all wanting. Bahauddin prays outright at one point (*Maarif* 1:151–153) to be given sacred texts to transmit. We hope we have caught the splendid daring of those sections, the casual dailiness of others, and the juicy exuberance of more notorious parts.

What strikes a reader immediately about the entries in Bahauddin's book is their surprising immersion in the world of desire. He prays for his cravings to be more intense. He feels the divine moving in him when the energy of his desire increases. He reminds one in this regard of William Blake. *Energy is Eternal Delight. Eternity is in love with the productions of time.* There is in Blake and Bahauddin a wisdom of energy. What nourishes body also nourishes soul. *Without contraries is no progression.* Bahauddin prays explicitly and often for his wantings to be sharpened. He means to live the body's life wholeheartedly, and as consciously as possible. *Better kill an infant in its cradle than nurse unacted desires.*[7]

Annemarie Schimmel refers to "the bizarre sensual imagery"[8] of Bahauddin's diary. The Rumi scholar Franklin

[7]All of the italicized sentences are from "The Marriage of Heaven and Hell," *Blake: Complete Writings,* edited by Geoffrey Keynes (Oxford: Oxford University Press, 1966), pp. 148–158.
[8]*I Am Wind, You Are Fire* (Boston and London: Shambhala, 1992), p. 32.

Lewis calls some of the entries "psychedelic."[9] We would see this strangeness as a sign of Bahauddin's radical health. Rumi says that form itself is ecstatic, that just having a shape and sentience is a state of pure rapture. Bahauddin says that being conscious in *all* the ways we have—in our transcendent mystical visions as well as in our fears of authority, in ecstatic prayer as well as in anger and annoyance, even in epileptic fits—every form of awareness gives a taste of God's presence. We would call Bahauddin a *juicy* mystic, by which we mean he loves the various intensities of a loving human awareness. Bahauddin loves the juiciness of the body and *through that,* union with God. He loves the flavor of human exchange, and the radiance of anything that happens. He is up early one morning, and a dog's barking interrupts his contemplation. A dog barks in the thirteenth century, and we hear it (1:381–382). The small tastes he gives of village life from seven hundred years back are exquisite and palpable.

For Bahauddin, having a clarity of being and strong desires is important because they make possible a richer manifestation of the divine. The vibrancy of the life-force allows God's presence to be more strikingly vivid inside form. *I was a hidden treasure and I* desired *to be known,* says one Islamic hadith. Bahauddin says that the desire of the divine for self-knowledge comes through the vitality of *our* desiring.

One of the most startling examples of this is in the *Maarif* 1:327–329, Bahauddin's account of the morning he woke up wanting the daughter of Judge Sharaf. She is one of Bahauddin's wives, as is Bibi Alawi in a similar account, 1:381–382, but nevertheless these are daringly libidinal notes for their time and perhaps even for ours. Professor Furuzanfar, editing

[9]*Rumi: Past and Present, East and West* (Oxford: Oneworld Publications, 2000), p. 85.

the *Maarif* in the 1950s, loves the boldness of the intimate revelations, their honesty and strength, but he also implies that these comments of the great mystic may have been irresponsible for his position. "We must remember that Baha Valad [Bahauddin] was a prominent leader of the Muslims. He was engaged in teaching and preaching, as well as being the chief jurist and arbiter of religious cases. His responsibility was in the direction and refinement of the outward and moral behavior of numerous disciples."[10] We hear in his sexual openness rather the force of a sincerity before God that overcomes any conventional standards. Bahauddin is naked in the expression of his faith, and in his living. His authenticity is his magnificence.

In the title, *Maarif,* may also be an implication that these paragraphs come from the state of *marifat.* Bawa Muhaiyaddeen[11] often talked about the four stages of enlightenment as being *shariat, haqiqat, marifat,* and *sufiyat. Marifat* is the completion of those stages, *sufiyat* being off the charts completely. We will never get notes from *sufiyat.* Nothing can be *said* of, or in, that region of consciousness.

Marifat is gnosis, knowledge of God, the knowing that comes from the original light given to human beings, said to be concentrated in the middle of the forehead. Focusing there brings a meeting with the guide of your soul. *Marifat* is the containment of infinity in an individual, when one is floating in, and moving with, the ocean waves. No day or night, no

[10]Badi-uz-Zaman Furuzanfar, *Maarif: A Collection of Preaching and Sayings of the King of the Erudites, Bahauddin Muhammad Hossain Khatibi of Balkh Known as Bahauddin,* vol. 1 (Tehran: Zahuri Books, 1974), pp. d–h (4–5).

[11]Coleman Barks's teacher. He died Dec. 8, 1986. Of the books available, the best introduction to Bawa Muhaiyaddeen might be *Questions of Life, Answers of Wisdom,* vol. 1 (Philadelphia: Fellowship Press, 1987).

birth or death, only the pure subjectivity of the whole. Hence the frequent mention of flowers in Bahauddin. Flowers know without subject-object duality. *Marifat* comes through presence, the full energy-field and its form, the flower's flowering and fragrance.

Marifat is a crossroads where Rumi and Shams look into each other's faces. Moses on Sinai asking to see God face-to-face occurs at the transition from *marifat* to *sufiyat,* as do Muhammad's night-journey and Jesus' last supper. We feel it in Bahauddin's relentless demand not just to meet the divine, but *become* it, and also when Shams pushes Rumi's father's book into the fountain, breaking his reliance on written wisdom.

"Mysticism" is a vague, imprecise English word, but it *does* refer to something. Mystics themselves are uncomfortable with labels and with language in general. Stubbornly experiential, they speak of tasting and of catching a fragrance from the ineffable. Bawa Muhaiyaddeen was asked once what it felt like to be him. He made the little sipping noises of a nursing baby. Mystics have a way of being and knowing that is not bookish. It's a taste and a fragrance, coming through presence and through the senses. It arrives in how we are with each other. "God's secret gets told in how we love."

Rumi said that his father "came from a long line of deeply mystical souls who passed on rare and subtle points" (Discourse #16), secrets that could best be transmitted, not in poetry, not in words, but through the way of retreat and openness to presence, through inner dialogue, the conversation and practices we feel produced this book. The Sufis of Bahauddin's time felt that the deepest transmission comes not through books but through presence.

The book of the Sufis is in how we talk
together in the new snow, the pure heart.[12]

Bahauddin was known throughout the region mostly for
his daily discourses, where he openly attacked the ruling king
and powerful philosopher/consultant Fakhr-e Razi. Promi-
nent theologians and learned jurists came from miles around
to hear him. Those talks would have been considered his most
effective means of publication. The rare, laboriously hand-
copied collections of his sayings *(Maarif)* were esoterica, of ne-
cessity for the eyes of only a few, and until this collection
almost completely unavailable in the West in any form.

Rumi regrets that he ended up in the place which gave
him the name we know him by, the city of Konya in Rum,
Roman-influenced Anatolia, where, he complains, there is no
lineage like his father's, so that he (Rumi) must compose *po-
etry* to keep his listeners *entertained.* He feels like a cook who
doesn't like tripe, but whose guests do, so he must reach his
hands into the repellent entrails to wash them and fix the dish
he doesn't like, which happens to be the most magnificent
mystical poetry ever served.

What we hear that is so beautiful in this notebook is the
ease and integrity, a companionable spontaneity between
human and divine, the Friendship, a placeless, ineffable *pres-
ence,* or "with-ness" *(ma'iyat),* a nearness flowing through all
beings. *With you wherever you are,* says Qur'an 57:4. We hear
the inexplicable but real merging of pronouns. N. J. Dawood
says of this phenomenon, in the Introduction to his translation

[12]These two lines of poetry are quoted without reference in Badi-uz-Zaman Furuzanfar's
Life of the Mowlana Jalal ud-Din Muhammad Known as Mowlavi, 4th edition (Tehran:
Zavvar Books, 1982), p. 32. As far as we know, this biography of Rumi has not yet been
translated into English.

of the Qur'an, "God speaks in the first person plural, which often changes to the first person singular or the third person singular in the course of the same sentence."[13] Bahauddin also switches seamlessly, in many places in the *Maarif,* from the personal *I* to the divine *We* (of the Qur'an), then back to the personal. This fluidity is part of Bahauddin's contribution to mysticism. His text is a melding of identities, a tree of voices. We honor that with our radical treatment of quotation marks within his text. Mostly we leave them out. There are no quotation marks in the thirteenth-century Farsi of the *Maarif.* (Quotation marks do not appear until modern Farsi.) But in any case we feel that the mystery of who is speaking, and to whom, is deeper than rules of punctuation know. Bahauddin, in his several selves (see 1:277–278), sometimes does not know who is giving the words. Mystery moves through him as it listeth, and stays unnamed. The Friend is helping with Bahauddin's tandem text. Sufis say God rides the outbreath as the visible, manifest world, existence (text), and on the inbreath as nonexistence, the hidden, invisible universes (inspiration).

Bahauddin stands before us as a multidimensional traffic junction, not as a poet, though a maker of wild paragraphs, nor as a coherent theologian, although a brilliant igniter of images in the cave of the unknowable.

Having emphasized the eccentric originality of Bahauddin, we must allow the other, more reasonable, perhaps more practical, conventionally religious side its rebuttal time. That side is not his primary energy-field, but to fairly present Bahauddin, we must accommodate 1:150. Here are some sentences from that section: "The meaning of worship is this: we resist the urgings of the physical in order to enjoy the

[13]N. J. Dawood, trans., *The Koran* (New York: Penguin, 1956), p. 1.

grandeur of the unmanifest. . . . Either you stand and act from your heart and soul, or your life will flow from the animal soul, the *nafs,* your lust and greed, which are qualities of what dies and does not surrender to receive the compassionate grace."

We considered leaving this entry out, given that it is a strong expression of the conventional body-soul division that William Blake so hated. We do see Bahauddin in Blakean terms, though less revolutionary.[14] Blake felt that a body-soul division such as that proposed here is the source of much cruelty, sexual repression, and crushing of joy. We agree, but there is another side. Human beings *do* have lusts and greeds and gulpings and laziness that obey their own powerful, not-so-eternal, prompters. Following them, we sometimes manage to end up in places no one would mistake for the soul's house. There *are* mistakes we can make, even as we hear other voices coming from the intuition, the soul, and the heart. The conflict and the implied *limits* that this entry acknowledges are real. The body requires discipline to truly and deeply incarnate the soul. As Jewish theologian and philosopher Abraham Heschel notes in *God in Search of Man,*

> We must not disparage the body, nor sacrifice the spirit. The body is the discipline, the pattern, the law; the spirit is inner development, spontaneity, freedom. A body without a spirit is a corpse and a spirit without a body is a ghost.[15]

[14]The English poet William Blake (1757–1827) lived six hundred years *after* Bahauddin, of course.

[15]Abraham Heschel, *God in Search of Man* (Philadelphia: Jewish Publication Society of America, 1959), p. 341.

Bahauddin may, as he often does, be addressing a particular person in 1:150, one who needs religion-sanctioned boundaries as a practical matter, so the truth may be partial. Body and soul *do* dissolve to a single knowing and wanting, and there *is* a divine subjectivity which can look through the lens of human desire and make it part of the mystery.

The side of Bahauddin we most delight in is his love for human energy in every form. We hear him saying inclusively with Whitman that we are large and contradictory beings inside these reckless, exquisite forms. But he also draws the blade of *NO* as well, the defining limit that opens us to spirit in another way. Both stances are true, vital, and necessary. They support each other. We shrink from admitting it, but Blake's revolutionary proverbs, wise and delicious as they are, are not the complete traveling bindle. *Exuberance is beauty. Energy is eternal delight.* Not always. There is a fair share of *stupid* exuberance and energies that are determined to destroy our soul-consciousnesses. Finding the balance between discipline and surrender is a continuous human puzzlement, the ultimate live issue. Bahauddin lives inside that question with many of the rest of us. And it must be stressed that he *adores* the Qur'an, being a devout Muslim. He had the entire text memorized, and he puts verses of it in everywhere, whenever they occur to him. There is at least one case where he says, "A verse of the Qur'an comes to mind, and although it is not related to this discourse, I will quote it." His enthusiasm for the Qur'an is compelling and genuine.[16]

Coleman Barks and John Moyne

[16]All reference numbers within the text, unless otherwise noted, are to the Qur'an, sura:verse. It should be noted, though, that Bahauddin rarely quotes whole verses from the Qur'an. He takes one sentence or a few words that are relevant, or even not relevant, to his line of thought and writes them in Arabic.

A NOTE ON TRANSLATION
AND VERSIONS OF *SAMA*

There are huge impossibilities in bringing any mystical know-
ing into language. What gets transmitted through *presence* be-
comes diluted and distorted when spoken. Even moreso with
the transition from that to dried ink on a page.

Then there are the eight hundred years between when
these notes were written down privately and now, as they take
form in American English and move into publication for
twenty-first-century readers. Difficulties proliferate, but the
attempt still must be made.

The process is this: John Moyne selects and translates ex-
cerpts from Bahauddin's Persian prose into English with some
explanatory notes, interpretations, and minimal changes to
make the archaic language and theological terms understand-
able to general English-speaking readers.

What we do with the text then, the "second translation,"
which you will read here, feels more like mystical play. It is
done by Coleman Barks. He tries to sense something like a
presence moving within the images and ideas. This part of the
translation, when it's working right, is done not with the
mind but with an emptiness in the soul. Work with mystical
text is not scholarly work. It's making oneself available to an
attunement with other presences, which is more like love than
studying, more like tasting food than reading a menu. So this
is not word-for-word, "faithful" translation. It is amplifica-
tion, interpretation, and spontaneous contemplation on what
Bahauddin wrote. A mystic hopes for *transmission*.

Consider Rumi's use of his father's notebook—the four-
birds section, for example (1:121–123). Bahauddin put down a

few sentences on the four birds that live in the human psyche (*Maarif* 1:221–223). He is commenting on a Qur'anic passage (2:260–62), which does not say what the four birds are. Rumi then expands his father's theme about the necessary killing and reviving, the transformation of the bird-*nafs* in Book Five of the *Masnavi*. He circles round the theme with stories and discussion for a thousand lines: the duck of urgency, the peacock of self-display, the rooster of lust, and the crow of ownership mania. The case could be made that all of Book Five's four thousand three hundred and thirty-eight lines are amplifying this theme of transforming desire-energy into soul-strength and compassion.

What Coleman does with these notebook entries is an expansion, but nothing so extended as Rumi's enlightened flights.

Shown below are John Moyne's renderings of *Maarif* 2:12 followed by Coleman Barks's second translation. The nine images have been numbered. We chose this passage to illustrate how we work because of our interest in the subject and because this is probably the most elaborate instance of the amplification process; that is, we have added several details, as well as summary passages, which one may see here by comparing the literal translation done by John Moyne to what Coleman composed as the second translation. The entry addresses the nature of *sama,* the ceremony of listening and moving to music and spoken and sung poetry and scripture that has developed in Sufi circles.

#1: *Sama*—that is, hearing songs and spoken words with music—is unpleasant if it is unrhythmical and proper if it is rhythmical.

Second translation: Deep listening has a pulse. It must throb, or it is not alive.

#2: Similarly, unpleasant speech cannot be amiable.

Second translation: The words and music of *sama* should flow and follow naturally as a conversation among friends.

#3: *Sama* is like a goblet that pours seeds of speech into the bucket of the ear. If the seeds are rotten, you cannot blame the goblet.

Second translation: As a scoop pours seed, song pours into the bucket of hearing. There may be a few rotten seeds, words that aren't right. Don't blame the scoop.

#4: Songs are like bottles with variations in their forms and colors, such as Baghdadi, Samarcand yellow, red, or crystal.

Second translation: Glasswork takes many shapes. The inward Baghdad curve with its translucent yellow, the Samarcand crimson, the spherical crystal flasks of Bokhara. So it is with music and poetry: *sama* should have an elegant variety.

#5: People open their houses to serve beverages not poisons. But poisoning and corruption are accidental events. Only rogues use foods and drinks for their mischief, and they will be cursed because of their reputation even if they do an honest act.

Second translation: When we set extra tables and open doors to invite guests in, we don't serve them food that's gone bad. When that happens, as it will, it's an accident. But if someone is known to have *intentionally* served tainted meat or drink, the curse of having done so will never leave, no matter how many generous actions accumulate. Let *sama* be fresh and lovingly prepared.

#6: The acts of singing and dancing are like thunder; if extended too long they will die.

Second translation: Poetry spoken with music and movement should move along like spring thunder: emphasis,

a softer stress, a space of silence, more thunder, then the dying out. It never goes on too long.

#7: When song doesn't have moments of witticism, its praises are false.

Second translation: If laughter isn't underneath and inside *sama,* if there's no bright, self-humbling wit, the praise-words will have no truth; the exaltation, no majesty. Without humor, *sama* becomes leaden and stern.

#8 & #9: The human body is divided into parts, and each part enjoys a type of song. For example, appreciation of music by external ears is different from internal (mental) feelings, and these two types of perception may be in conflict with each other.

Second translation: Each body part has a musical preference. Each enjoys *sama* in a unique way. Ears absorb sound differently than does the heart. Words spoken with plucked string may jar the eardrum but delight the heart-center, or the opposite: something mellifluous may disgust your soul's intelligence. Kidneys hate it when the fingers tap rhythm. The drumming makes them nervous. However, the lungs love everything fingers do.

With *sama,* let these nine metaphors guide you: a heartbeat rhythm, a lively conversation among friends, the smooth pouring of seed from a scoop, the elegant variety of glasswork. The feel of a banquet, spring thunder, and laughter in the outdoor air. *Sama* must move with its multiple harmonic systems working like the organs in a human body, each having its separate function and delight, while carrying along together the *whole* human presence, composed of body, heart, soul, and luminous intelligence.

We understand this notebook entry as experiential commentary by a master practitioner. We are not so much interested in

a literal recopying but more in some exploration of Bahauddin's insight. He is saying what the atmosphere of a *sama* should feel like. The deep listening-together of this practice has been loved and refined for hundreds of years in many cultures. It is meant to encourage the flow of divine being through the opening hearts of those willing to take on the emptiness of a reed flute, a drum, along with the plucked strings of language and imaginal awareness. *Sama* is the play of creator moving inside creation.

The formal, traditional *sama* done inside Sufi orders has come down as one of the most deeply moving ceremonies on the planet. It is a profound remembering of the opening that came with the meeting and separation of Rumi and Shams. In *The Feats of the Knowers of God,* a massive fourteenth-century oral history of Rumi's circle compiled two generations after the poet's death, Aflaki records the beginning of one of the *sama* assemblies that Rumi led:

> God is entirely ecstatic delight, and whoever has not experienced delight does not know. I am that ecstatic delight and wholly immersed in it. Faith is entirely ecstatic delight and passion. At that he [Rumi] let out a shout and began performing the *sama*.[17]

We honor the traditional line that descends from that insight. Hardly anyone in the West knew of the Persian mystics for five hundred years. Then Goethe, Emerson, Whitman, and others discovered them. The poet Gary Snyder was reading

[17]Aflaki (d. 1356), *The Feats of the Knowers of God,* translated by John O'Kane (London: Brill, 2002), p. 128. Shamsudin Ahmad al-Aflaki was a contemporary of Rumi's grandson. His book is one of three early sources for the details of Rumi's life and those around him.

Rumi on the tanker in the 1950s. So the material began filtering through some appropriate portals. The recent, and continuing, passion for the Persian mystics, though, is unprecedented. It has been claimed that Rumi is the most-read poet in the United States. Surely Shakespeare and his *poem unlimited* must be excluded from such figuring. But even if Rumi is third or fourth or twentieth, it is still remarkable.

And there is a version of *sama,* if we can call it that, that has begun to take various forms in this country. These meetings are happening outside the sponsorship of any organized religion. It is not unusual for a theater or church in a large U.S. city—Houston, Boston, Washington, Kalamazoo, Boulder, Minneapolis, Santa Fe, Louisville, Seattle, Missoula, Charleston, or Athens, Georgia—to have a Thursday evening, or a weekend night, where a thousand people sit and listen to mystical poetry (mostly Rumi, Hafez, Kabir) and music for two hours. These events do not have the feel of performances but of gatherings more inward and contemplative. Often there is no applause. When Joe Miller was alive, he would come and sit in the front row of an audience in the San Francisco Bay Area, which is the capital of this experiment. At the end he'd stand up and trumpet, *Ya Fattah* ("the Opener"), one of the Sufi names of God. Everyone would yell back, *Ya Fattah, Ya Fattah.* There seems to be a growing call for these evenings, and some deep nourishment being given. We don't want to make too big a deal of this phenomenon, but we don't want to make too little of it either. Rumi in the past decade has become suddenly and extraordinarily current in America and England, and to a lesser degree in Poland, Germany, France, Finland, Taiwan, Israel, and other areas.

The new *sama* evenings are in part an extension of the ex-

perimentation begun in the 1950s among the Beat Poets in San Francisco—Allen Ginsberg, Kenneth Rexroth, Lawrence Ferlinghetti, Gary Snyder—and in the 1960s and 1970s by Robert Bly, Etheridge Knight, Ann Sexton, and others, testing the various combinations of musical instruments with the spoken word, song, and chanting. Dylan Thomas brought in the strong Celtic strand. Traditions from Africa, the Indian subcontinent, and Native America are contributing to the mix. Leonard Cohen. Kurt Cobain and William Burroughs. As a planetary culture we are feeling our way along back into a gorgeous area of the psyche. *Sama,* Sufism itself, and *zikr* ("the remembering of God") transcend categories of religion, nation, and culture to explore something more essentially human—how we hear messages from spirit and move in response.

Perhaps if one were to ask an American crowd attending a typical poetry reading which they would rather hear, poems involving personal events or impersonal luminous wisdom poems, they might say, Go easy on the wisdom. We cannot absorb much of that at a sitting. But we can take all the personality you got. This is not so much the case in these non-affiliated sessions of *sama.* Those audiences seem more ready to go to any of several audition-worlds, the outer, exoteric world of personality and politics being one. The inner, theophanic sublime, another. The oneiric, the hermetic, the purely playful, are others. A performance audience keeps its distance more than those who come to a deep-listening *sama.*

Critics of these evenings say there is in them an avoidance of real work, a dangerous ease and consolation. Andrew Harvey feels, with the apocalypse upon us, that we should bear down and go for full and immediate transformation. We have no argument with Brother Andrew and concur with his

evangelical urgency. We hope the poetry and music and the listening are evolving into something more transformative. Besides, what he is calling for must happen within each individual. These evenings do not prevent that. There may be some softminded fluff coming through in them, though, some ecstatic self-hypnosis, and too much attention to trance states. We must always remember Rumi's severe side, the discipline and the regimen, and always bring in harsh evidence. Against ourselves. *Love Comes with a Knife* cannot be read with a mellow voice.

The mystical effect of *sama,* when it happens, must be in the possibility that language *can* carry the psyche, so that sometimes there are presences being borne along inside poems and inside books. This is surely the deep reason we love bookstores and poetry readings and books themselves so much. We are looking in those for nothing less than friendship with great and fiercely alive souls, and sometimes we find it. This is not wishful thinking but rather experience. The mystery that was, and is, Jalaluddin Rumi and Shams Tabriz can inform us with their very being, when words are doing their work.

> Listen to presences inside poems.
> Let them take you where they will.
>
> Follow those private hints,
> and never leave the premises.[18]

[18]This Rumi quatrain is from *Unseen Rain,* p. 37.

The purest commentary[19] on *sama,* and the most demanding, comes from the tenth-century Sufi mystic Hallaj, who says that *sama* is connected to *ilm* (wisdom). He says you cannot enter that ocean of wisdom without audition. Nor can you attain gnosis *(ma'rifa)* without spirit, peace, and fragrance *(al-ruh wa al raha wa al-ra'iha).* *Sama* must be done with love, from within love. And as Hallaj says further along in his ladder of spiritual states and the conditions necessary for them, You can't have love *(mahabba)* without longing *(shawq),* or longing without ravishment *(walah),* and without ravishment you will not enjoy the presence of Allah. That good man and true, Bill Moyers, asked Coleman once on a PBS show, What is longing? Coleman said something about the gold light of early spring sunsets in Chattanooga when he was a child. What would Coleman say, we wonder, if Moyers now asked, Coleman, what is ravishment?[20]

Coleman Barks and John Moyne

[19]The literature on *sama,* as a quality of attentiveness and as a performance ritual, is an immense world unto itself. For those interested, some points of entry: Al-Ghazzali: *On Listening to Music.* Translated by Muhammad Nur Abdus Salam. Chicago: Kazi Publications, 2002. Nasr, Seyyed Hossein. *Islamic Art and Spirituality.* Ipswich, Suffolk: Golgonooza Press, 1987. Racy, A. J. *Making Music in the Arab World: The Culture and Artistry of Tarab.* Cambridge: Cambridge University Press, 2003.
[20]The Hallaj quotations are taken from Carl Ernst's essay, "The Stages of Love in Early Persian Sufism," in *Classical Persian Sufism: From Its Origins to Rumi* (New York and London: Khaniqahi Publications, 1993), p. 442.

THE MANUSCRIPTS

While the eminent Iranian scholar Badi-uz-Zaman Furuzan-far was writing his biography of Jalaluddin Rumi, he obtained a handwritten old manuscript of the *Maarif* in Tehran. It belonged to Professor Ali Akbar Dehkhoda. The last sentence in the manuscript says that it was copied in the year 1549 by al-Mowlavi al-Qunavi. This became the first part of Volume One of his edition of Bahauddin's book. Volume One has two other parts signed with two other names. Later Furuzanfar located a facsimile of a manuscript in a university in Istanbul. This consisted of three sections of the *Maarif* compiled by three editors in the sixteenth century. Other discoveries of texts were made in the library of Hagia Sophia and in the Konya museum. These manuscripts are from the first half of the fourteenth century. Furuzanfar published Volume One of the *Maarif* in 1954 (second edition, 1974). He used the sixteenth-century manuscripts as a base and the earlier ones for comparison and correction. The arrangement of this first volume is in short chapters, not like a diary but more like a collection of sermons. Volume Two, published in 1959, is based on the oldest manuscript found in Konya, and it *is* in diary form. It may even contain some of Bahauddin's own handwriting, and perhaps marginal notes by his son. This has been suggested by a comparative analysis with samples of Rumi and Bahauddin's handwriting that are known to be authentic.

Professor Furuzanfar has no doubt that what we have in the *Maarif* is Bahauddin's personal record, or sayings, the style being very distinctive and bold throughout. He maintains that it could not be the work of the copyists or of students taking down notes from discourses. One estimable characteristic of

Bahauddin is that he had the entire Qur'an in his memory, and for most of the entries he quotes one or more appropriate verses in Arabic. Obviously he did not have to carry the Qur'an with him and search through it for proper quotations. The *Maarif* is an intimate spiritual traveling notebook, quirky, eclectic, and passionate. Furuzanfar, and Annemarie Schimmel as well, see Bahauddin Valad[21] as one of the creators of a wholly original line of Persian poetic prose.

John Moyne

[21]Bahauddin's full name was Muhammad bin Hossain Khatibi Balkhi, variably known as Bahauddin Valad, Baha Valad, and Bahauddin.

THE DROWNED BOOK

(Selections from the *Maarif*)

Praise for the unnameable mystery,
conversation with the divine, spirit-visions,
 commentary on lines from the Qur'an, herbal
remedies, dream accounts, erotic episodes,
 gardening hints, notes on discourses
and exercises for his students, reports of ancient
 ceremony, notions on the value
of work, digestion as a central metaphor
for awareness, advice to particular people,
 lots of self-critique,
 cosmological, metaphysical,
 psychological speculation,
 and other, unclassifiable, material

Translated by John Moyne and Coleman Barks

BOOK ONE

BLUE ROBE[23]

Show the true way. (Qur'an 1:6)[24]

I have been given a taste for what is beautiful. Like milk running through my body, the gates open. I wear a blue robe woven of six directions with watercolor images flowing over the cloth, a thousand kinds of flowers, yellow jasmine, wild iris. Orchard corridors, handsome faces on the street, I am composed of this beauty, the attar of pressed plants, rose oil, resinous balsam: live essence, I am the intelligent juice of flowers.

1:2–3

ONE OF THE WAYS GOD TASTES

In the middle of praying I was thinking about the nymphs of paradise again, said to be half-camphor, half-saffron, with their hair of pure musk.

Then I remembered the old saying about such and such whose head is soaked in shame, with his foot bound tight in truthfulness.

[22]The numbering here refers to Furuzanfar's edition of the *Maarif*. Books One and Two of that are divided into *fasl* (chapters) that are marked by the word FASL in dark ink and a chapter number. To avoid confusion, we have *not* used these chapter numbers but rather the more exact page numbers. Thus, 1:144–145 would indicate a passage in Book One beginnning on page 144 and ending on page 145, *not* Chapters 144 and 145.

[23]The reader may want to consult, from time to time, Coleman Barks's freewheeling Commentary at the end of this volume for observations on various entries and other matters.

[24]All subsequent numbers in parentheses in the text also refer to the Qur'an.

Then I recalled the qualities of God: compassion, generosity, elegant intricacy, luminous wisdom, mercy, beauty. I became grateful that I know the taste of some of these qualities, according to my limited capacity, and even beyond it.

I see a long table spread with a tablecloth. On it are the powers and qualities and creations, the seven stars from which flow our pleasure here. Even in my unconsciousness, God enters my desire and my soul with the *taste* of those qualities.

I feel myself *becoming* one of the ways God tastes.

1:4

THIS CUP OF SEEING, MY WINE

I sit in front of God, moaning and grieving and praising, finding new ways to show my love, like songs being sung to a rebeck, then tambourine and ney, then the music of all three.

Every moment this cup of seeing fills with vision. This is my wine. I drink the given moment, and through my limbs and trunk and head the blooms are opening. This is health. Any other feeling, disease and deadness.

1:8

SLEEP-TREE

I was sitting, wondering what I should do, when I received this revelation: Open your heart. Feel the closeness with God. Look inside yourself. Tend the awareness there.

Which led me to think, There are two entities here, God and myself. God, the dazzling mystery; me, the confused mixture of dead and bitter that I must suffer through to reach God.

Tangled in these thoughts, I get drowsy. In sleep I become a night-silent tree, rooted in nonbeing. As I wake, the tree puts forth branches and leaves. Eyesight returns; limbs move in the air. My heart feels like flowers opening along a branch. Prayer expands to become fruit, and nonbeing is the taste of language in my mouth.

FRAGRANCE OF AN INVISIBLE FLOWER

I see the essence of being alive as water flowing from the invisible to here, then back there. My senses know they came from nowhere and will go back to nowhere.

I recognize the one step from existence to non and from nonexistence to here. When I deeply know my senses, I feel *in them* the way to God and the purpose of living.

> Look at this surprising flower
> which cannot be seen, and yet
> its fragrance cannot be hidden.

God is the invisible flower. Love is the flower's fragrance, everywhere apparent.

MORNING SALAAMS

Early each morning I sit in the mosque. As people come in, they give salaams, *The peace of God, God's peace.* Then they do a full prostration in front of me. I know what God is doing: composing my soul so that it appears with such beauty to these people that they want to honor the workmanship.

Even if they see my hypocrisy, the conflicting emotions, my love of flattery, still, mostly they recognize the divine attention that has been given to me. I am grateful for the way my soul is sometimes drawn to move with other souls and then separated from them. I observe here a law of soulmaking with exciting possibilities for understanding.

Scenes of how it operates appear: People in arctic cold, others in the tropics. Oceans, high desert canyons, wooded valleys, all in harmony with "the One who has no partner." There is a group that sings and moves in pure joy; another is quiet in the midst of tremendous grief and carnage. A tree bristling with thorns: jealousy, meanspirited revenge. Then the white jasmine flowers bud, open, and drop the gift of themselves.

Why are we shown this? So we can appreciate the whole as given. When I am grieved and without hope, I accept that as grace, as well as the removal of pain. A deep knowing comes as we are shown, receive, and grow to love both.

BOILING POT

Lord, you give dominion (12:101). I said to God, Power on the material plane is trivial compared to what occurs in the unseen.

You taught me to interpret traditions (12:101). And you are teaching me how to understand the stories that appear, and that I hear, in sleep. I stay *vividly alive,* whether dreaming or awake.

Creator of heaven and earth (12:101). You separate the mundane from the sublime, and you open a curtain so I can sit and enjoy the two worlds.

I take refuge in both (12:101). Both belong to you, but I have fallen in love with the other, the next, what is unseen now. Take this apparent one away. I am tired of waiting for the life to come.

So at this point what should I do? Where does my heart lead me? Maybe I should consider the range of pleasures available, the comforts of resting in the body and the other intensities of nonbeing. Both are given. Everything I say is a remembering of God.

When I think of a human soul, I see a boiling pot, restless confusion. Pleasure comes from you. Nonexistence following existence with existence then coming in again, being nursed and sustained by you (11:6).

I ask for guidance with tremendous awe, and in close companionship too. The gifts arrive with familiar good humor. I ask to be satisfied in my sexual wanting. You give that, as well as the source of sex. When hungry, I ask you for food. Who else would I go to? Where else can I look for work?

I go to your door to pass the time. We walk out together. In five-times prayer I ask you to accept this homage, and please, to keep my body vibrant with new varieties of favors and the familiar pleasures too.

I don't always see wonders around me. Sometimes, in trouble, weary and sick of this life, I go to your door. No matter my mood, I go to you.

A SWEETNESS IN DISTANCE

Living moments come from you: eyesight, form, understanding, intellect, soul, everything. So why can't I speak more directly? Why can I not stand in your presence and press my lips to yours? I want my body to feel you pouring through! Why not?

Revelation in response: *What you say is observation not conversation. Let the asking be more of an experience.*

But I am treated like a mineral, a bit of sand blowing about with no sense of you and no knowledge of myself. I sit in quietness to feel the glory and the love.

Another revelation: *I show myself in minute doses. Take small sips.*

There is such sweetness in this distance. How would it be to be closer?

STILL GROWING

Inside and outside my body I see clear cold streams beside the flowers, and after I die, the corpse will find its way back to those and the soft air around them. Our soul-seeds come from the invisible, and here we are, still growing. We fade and go to seed. We die. New seeds slip into the ground of the unseen, each to grow its own unique lineage beside the water. God provides this continuing.

Qur'an 64:14 reminds us that there may be enemies among those close to us. Be careful, and remember that when you forgive and overlook insults, you are letting grace dissolve resentment.

FORGIVENESS AND IMPULSE

To know whether a particular sin has been forgiven, look within to see if you still feel the urge to do it. If you do, it hasn't. Keep praying for the impulse to be removed.

LOAVES AT TABLE

Someone with no compassion for anyone else will have no mercy on himself. If you commit a cruel injustice against a stranger, you will do the same or worse to yourself. Every

forgetful, mean act comes back. You will find yourself loaded with what you literally cannot bear. You're not strong enough. The curse of wandering without joy or purpose will walk with you for years until you come upon that which was your first shelter, the cradle of the manger.

A horse strays into a cave full of lions. You move deeper into your desire for sex, for art and wealth. There will come a time when your life is a blank (76:1), but has there ever really been a time when human beings were not cared for? For thousands of years we had no identity, yet we managed to arrive in this amazing moment, this brightly conscious lifespan. Who gave us such restlessness to *know* and *be?*

In the oven of the womb you were a wet lump getting baked for the world's long banquet table. You have no sense of that process, the skills that brought you to this fragrant, generous moment. Loaves of bread do not know as much as their bakers or even as much as those seated at table.

You have been given the perception you have and your willingness to surrender—*not to be in control,* but rather to worship with and praise. These are important limits to acknowledge, as definite and as clear as the fact that inorganic objects like stones and pieces of metal cannot *see.* That's how you are with spirit and the beings who live in the spirit. You cannot see them or know their circumstances and purposes.

We know so little, and we are given gifts we have done nothing to deserve. We rise from dust, live our brief difficulty and triumph, then sink back to dust. It is sheer stupidity, and dustdevil arrogance, to question God's justice, or common sense or abiding compassion. Praise whatever you feel as indignity or humiliation, or even idiotic disaster. Praise that the divine presence is a knowing beyond our misunderstanding, and that that knowing nourishes all.

THE NIGHT VIGIL

Darkness has been given as a nightshirt to sleep in (25:47). Remember how human beings were composed from water and dust for blood and flesh with oily resins heated in fire to make a skeleton. Then the soul, the divine light, was breathed into human shapes. The work now is to help our bodies become pure light. It may look like this is not happening. But in a cocoon every bit of worm-dissolving slime becomes silk. As we take in light, each part of us turns to silk.

We made the night a darkness, but we bring shining dawnlight out of that. In the same way the mound of your grave will bloom with resurrection. Sufis and those on the path of the heart use darkness to go within. During the night vigil the universe is theirs (40:16). With all the kings and sultans and their learned counselors asleep, everyone is unemployed, except those wakeful few and the divine presence.

UNDER THE GARDEN

Someone asked why it is that such affliction and disaster come to those who are friends of God, the prophets. I answered that suffering opens the heart, and that's a good thing. Pain and difficulties are spring thunderstorms, dark above, flowers and laughter below. This visible world is calamity's home where the body hurts, while the soul grows more alive.

The death-community mourns, then looks for ways to please the body. They live the sadness of their inverted vision.

Notice how a dervish stays hidden underground in the heart, tremendously happy beneath his flourishing rose garden that has walls that are crumbling and overgrown, hardly walls at all. Meanwhile, those who live outside the heart maintain their ownership markers with perfect masonry and bright, snow-shining, precision edges, within which the flowers are stunted and discolored.

Devotion has two wings and each wing many feathers. One feather is a delight in five-times prayer, another in fasting, tithing, in caring for one's family and the other obligations given. The other wing has feathers for strength. One, the discernment to avoid the wrong company. Another, the determination to fend off those who would do damage and to protect the community from danger.

1:64–65

WAITING

We gave you victory (48:1). Granite breaks open with delicious water flowing through. Flint against flint brings fire, as a grieving person looks up with deeper love. From packed dark clay come green sprouts that will nourish us. We make a garden grow from you. What have you seen that makes you sad?

There is no reality but God (2:255), meaning oneness. Open into that. Scrape away the wishing and the careful figuring. What you most fear has already happened. Your container is *already* broken.

What if someone offers bread, then takes it away? Sometimes a father shows gold and silver to his young children,

then puts the coins away. They want their presents *now*. But the father is saving it for their weddings. If he gave it to them now, they would waste it, and later they would feel ashamed. God hides inside a cottonseed the strong canvas we use to make tents. Smooth silk waits in the wormy cocoons. If inept and immature thieves were to steal those—the cottonseed and the silkworm casing—they would have no way to enjoy the value.

RUST

God set a seal on their hearts (2:7). But being *sealed* is a closed state, as when a mirror rusts over. If you bury a mirror, the brown lichen will encrust the surface and keep it from reflecting.

You have discarded your heart-mirror on the world's midden heap, leaving it out in the weather for a long while. The images of eternity it used to reflect have now been lost.

With laziness and neglect the heart loses its ability to reflect the beauty around it. There are slowly accumulating consequences for what we do and don't do.

FARMING WORK AND ATTENTION TO FRIENDSHIP

I have said to the crude-minded Fakhruddin Razi and the dull King Khwarazmshah and several other joyless philosophers, With your way you leave behind the beauty of flowers and peacefulness and walk steadily into darkness. You ignore the obvious miracles in favor of smoke and ghosts. The false self of ego makes your decisions. You feel confused and blocked, but wisdom knows that this material world is a door to spirit. Specific actions are required, and careful attention must be given to friendship.

We live in a place where thorns and poisonous plants grow wild, but fruit trees, roses, and vegetables need tending. That diligent farming work is virtue. Fakhruddin and Khwarazmshah disagree. They're like the locusts who descend and eat crops (54:7) rather than help them grow. I wrap myself like Muhammad (74:1) in this robe of torso, limbs, and face, this splendid covering of phenomenal existence, where I grow toward some destiny I know not, only that I must live fully here to reach the next.

SUSPENDED

Recently a man from India, in love with the flow of his own speaking, was asked, "How do you see Bahauddin?"

"Suspended in the sky with rays of light bursting out from him."

"How do you see those of us who listen to him?"
"Chickens pecking around his feet."

It is true that my love for God delights my body. I feel illuminated in the same way that sexual desire makes my limbs and organs more alive.

1:92

THE WAYS OF ESSENCE

Now I will observe the nature of this being alive in the different ways we are. Essence can be known only in a living example. People are often dazzled by form because essence shines so in its qualities. Feelings of health and feelings of illness are not part of my meaning here. The green world, new friendships, discoveries, circumstances, the feel of water, our delight in the human body and its imaginings, these are areas where essence thrives. How we recognize anyone's presence, how people's lives register in the body, how soul goes to its guidance and agrees to the work it's given. Try to be more conscious of these living abilities, and be happy.

1:103–104

APPETITES

When you love God, God is loving you (3:31).

Can you say you have found true relief for your longing in the pleasures of friendship or in the sensual trance of desire? Muhammad advises that we merge with a wider love.

If you say you have found this expansion in friendship or desire, you'll be lying, though it's true people glow with wanting and grow pale when they think they're losing a lover.

The appetites feed to stay alive *in order to love,* and there is a vast passion within which these other drawings-together do their dance. A purpose threads through desire looking for more *ultimate* satisfaction.

<div align="right">1:110–111</div>

THE CALL TO PLEASURE

From the minaret the call to prayer comes to us from the outside in. Other callings come from inside us, the animal energies, the various wantings, even our attraction to the purity of angels. I notice that every part of my body and my awareness is ready to receive each of these cravings. I have more of them than most because I *ask* for more. They come as gifts. When my sexual desire gets satisfied, my entire body feels pleased and peaceful. And looking at beautiful women delights me greatly. Why are people so agitated about these things, when all they have to do is live in the love of the presence? I am faithful to that, and the way of pleasure and satisfaction has been opened to me. There are many different ways. Some have nothing in common with others. Mine is unique to me, and I enjoy it tremendously. The world I see is even more beautiful and pleasurable than the one we accept in common. Many people want to be like me, but I have no desire to be like them. Which proves that I have been given a more delicious life than the one they live. God knows best.

IMPUDENT BANTER

I have come to realize that the better friends I become with someone, the more impudent I get with him. Politeness is appropriate for strangers, but with a friend there's no holding back, no need for any restraint.

So consider this. There is no closer friend than the Friend, no one who endures more outrageous behavior than that one, and no one more accepting of, or responsive to, all the rank blurt and tease. Let the spontaneous metaphysical banter turn to flint, or get white-hot; it will still be held within the horizon of this Friendship.

IN EACH

I was wondering how any living thing can be familiar with the divine without having some of that within it. How do creatures rest and find their joy?

An answer came: Everything comes from me. I am in each compassion, companion, each calamity, lust, any conversation among friends, secrets murmured, a spray of sweet basil, determination, the changing nature of what you want, prayer, love, everything flows from and returns *here.* Leaf, stem, calyx, any cause and effect, every sleep's return to waking.

WHAT I HAVE JUST WRITTEN

It is because human beings have it in them to receive grace and taste the wine of eternity, because they can recognize hypocrisy and cleanse themselves of that and the other impulses that are destructive to love, that eventually they weary of form, these created appearances, and long for the source itself.

Such a person sees nothing to fear in the world, nor is he concerned with receiving rewards or avoiding any punishment in the here or the hereafter. He has no judgment either way on anything. His only nourishment is the presence of the Friend, feeling and remembering that closeness. When he or she dies, the organs quit their natural functions, and the real self fills with love and dies out of humanness to live in God.

My prayer is that what I have just written become true for me. Let lover and beloved live here in the same place, in my heart. As I write these sentences, I feel like I am seeing the Friend. This writing enters me like a bride wearing jewels filled with the light of passion and kindness.

PRISON AND PRESENCE

They ask, Can a person find the joy of the presence in prison? I say, Joseph the son of Jacob had that experience because he let truth flow through him, no matter what. When a good man does something against his nature, he worries deeply. He should also be happy for his remorse and for the suffering he

has caused himself and others, and even for his confusion over how to admit the mistake. He weeps to be cleansed. Let that crying and the love of God be enough.

There is always a back and forth from laughter to tears. When weeping comes, one is feeling separation. Then when laughter happens, we know we're inside the presence again. We never left. A child grows up happy living within the grace. Then he or she turns quiet and sad. The sense of being wrapped in presence diminishes. Only one who breathes the *zikr* without letup never loses the joy: no reality but you/in—there is only you/out. Those beings are very rare.

DOUBTING

Their knowing fails in the unseen. They doubt and stay blind to that reality (27:66). You can explain this world to a man who has been stone-blind from birth, but he will remain confused. His ignorance has no power to conceive the beautiful face of this world. The beauty simply remains what it is, in its glory. So when you are told about spirit, the hereafter, and you stay unsure, your doubting does not change, nor do the qualities or the *fact* of spirit and soul.

I was talking about the beautiful young women and the paradisal gardens with a wise man, my elder. He said, If you are preoccupied with these things now, you will continue to be in the unseen. Move instead toward the divine mystery, and only that. I replied that I see the paradise rivers *through God,* so they are always changing and giving various pleasures.

With you wherever you are (57:4). Ask for what you want. Then dissolve like honey in milk. The doors will open, and you will see that you are already living inside the presence.

1:137–140

THESE ATTRACTIONS

I was saying *Glory to God,* and the inner meaning of that came to me. If you desire elegance, the perfection of it is in the presence of God. The same with wealth, authority, dignity, *sama,* and *sohbet* (the deep listening and mystical conversation practices). All of these reach perfection inside the mystery. Whatever we love in this visible world, we are sure to discover its flaws.

We grow more alive, more perfect, when we take these attractions into the presence. Let them live inside our being drawn *there.* Every pleasure of light, color, taste, touch, fragrance, and sound becomes filled with our remembering. We go light-hearted, high-spirited (37:99). Even when I fear going there, I go, am held, kissed, and bathed in the luster.

Now I begin repeating *Allahu Akbar,* God is great, and I see the beauty of the visible forms of that greatness, physical strength, banners, a mountain cliff. Likewise, when I say the *zikr,* that conversation becomes a spring wind turning dead ground into roses, water running by, word of a friend's arrival. Saying praise together out loud brings into being a key that opens the heart.

DESCRIBING A TASTE

Someone asked me what *is* the knowing I speak of and how does the love I mention *feel*. I said if you don't know, what can I say? And if you do know, what can I say?

The taste of knowing love has no explanation, and no *account* of it will ever give anyone that taste.

THE BEAUTY OF A FACE

Say No power but you, until you become that surrender. Repetition engraves your habits of mind. Patient practice makes a stone a carnelian. Knowing grows roots in love and love in purity. Each day do some work in splendor (55:29).

When I am asked about the nature of love, I say nothing. I point to those thousands of surrendered, prophetic souls. Talking about love obscures the essence. Whatever transpires between lovers can never be said. It's a living mystery. Taste and feel it without verbal exchange. Relish it in your soul, your heart, your personality. Taste the taste with your entire body, and here in the tongue. But not by speaking.

As the soul enters physical form, let your loveself enter God. The beauty in a face is the look of mystery, the going in.

NO SURE SENSE

Say: No one knows the unseen except God (27:65).

With that text I put this question: How do you feel about doing work that brings no benefit to you or anyone? Aren't you always aware of a destination when you walk out your door? Do you ever walk out, look around in all directions, then go back into your house and sit there with no purpose, for no reason?

You often plan work without knowing what will come of it. You plant seeds with no guarantee they will sprout. You enter into a business deal with no sure sense it will make profit. Many do not reach the point they move toward, but that doesn't mean they stop trying.

Certainty comes only with work we do in the invisible, but we cannot know that. Journeys taken and seeds planted there never disappoint. The saints and hermits and prophets might be able to give us some of their confidence if we could work along with them.

APART FROM PURPOSES

After I die, and this body dries to powder, don't keep me ignorant any longer of how you move in the changes that occur. I love your actions. I know that everything happens *in you,* my true companion. When I see the motion, I see my being moving with you as their blood nourishes each detail, causing

them to bow in profound awe before their lord and nourisher (98:8).

Trees and the fruits they bear, any touch bringing pleasure, whatever comes through the senses influences intelligence. But I want more. How long will you keep me apart from the *purposes* that operate behind and within the senses? No more restlessness, no more humble submission. Let me burn *inside* presence.

1:147–148

A KING IN HALF-SLEEP

I wake from sleep within you. I turn and hold you in my arms, as a king in half-sleep thinks himself alone, then feels his bride next to him in bed, smells her hair, and remembers he has a companion.

Slowly waking more, he begins to talk. So I wake inside you, the pleasure, the soft-saying, the elegance of the hours we walk in wonder. I draw closer. When my servants ask of me, tell them I am near (2:186).

Then I remember Moses fainting in the presence, Jesus' face, the mysteries that the saints unfold, Muhammad's sure stance, lovers mixing together in their songs, and I know that I have been given *these feet* to walk the amazement you gave them.

THE QUALITY OF WHAT DIES AND
THE GRANDEUR OF THE UNMANIFEST

Anyone who denies the body's wantings fulfills a deeper long-ing from his soul and his heart and his faith. The meaning of worship is this: we resist the urgings of the physical in order to enjoy the grandeur of the unmanifest. Touching your forehead to the ground in five-times prayer acknowledges this intention, but you have done the opposite, honoring the promptings from your body and ignoring what you hear from the soul center.

You cannot have two foundations. Either you stand and act from your heart and soul, or your life will flow from the animal soul, the *nafs,* your lust and greed and forgetfulness, which are characteristics of what dies and does not surrender to receive the compassion of God.

BREAD AND PRAISE

I was thinking about the piece of bread I have just eaten and the drink of water I have taken. This revelation came: Each bit of bread and taste of fruit has a tongue and a language of praise that gets released when it enters a human body.

The same analogy of transformation extends to the influences that came from the stars and transmuted matter into the elements: earth, air, ether, fire, and water. Those in turn became plants which became animals, then human beings with their flexible way of speaking that can become praise for the compassion as well as the anger of God.

I saw bread and water dissolving and moving through my organs, carrying the qualities of the mystery. They were flowers with the ability to speak, saying, There is nothing that does not celebrate and praise (17:44).

Because my intellect and my memory are flowers in the hand of the mystery that supports and inspires existence and gives the scriptures, I pray to be given wisdom in the form of books to transmit the taste of love and the pleasures of expansion. Do not ignore these writings. The fallen angel Satan saw the appearance of Adam only. He did not see the essence. Inside these rough words are secrets. Don't miss them.

1:168–169

THIS GLORY OF EMPTINESS

Where is the wellspring of joy and grieving, of being and nonbeing? Does anything satisfy without a contrary pull the other way, toward deprivation? We want what we do not have. From the region of nonentity comes a cure for our longings for eternity, enlightenment, long life, the beauty of women, recognition, and dignity.

You are there in nothingness. I annihilate myself in your qualities. Consciousness dissolves beyond time and space. I watch the growing and the decay. In this glory of emptiness, where will I live? There's nowhere to land.

ONE HOUR

Alif Lam Mim

If God says *We,* meaning I AM, then any pronoun I use becomes superfluous. Designations fall like petals. Wisdom comes, and I feel such pleasure flooding me that I fear losing my sense of it. I tell myself, Inquire into how lover, beloved, and the other ways of loving exist as one thing.

As it is with God's qualities and human beings, so there is a unity with love. In the heart there is no room for differentiation, only oneness and the beloved. I would give away books, land, my virtues and reputation, everything, for one hour inside that presence.

WONDERING ARGUMENT

This is how God talked to Muhammad, saying, We have given you victory (48:1), There was companionship between them, We have sent down to you a book (4:105), and Have we not expanded your heart (94:1)? They spoke together like friends. Has anyone else had such an experience? And since the divine mystery is part of everything and everyone, must there not be such nearness inside everyone?

An answer came to this wondering argument. There are ways unique to each soul. One gets handed pain, another love, another lust. One must go through terrible punishments, another extensive comforting.

But the way of God with prophets is on another level, where miracles and grace and visions of the unseen world come. Aspire to that plane. Otherwise you will continue to speak with God about heat and cold, food, livelihood, sleep, waking, and the various human theories about mystery.

My prayer is this. When I am alone with you, let me feel the pleasure of a surrendered love. Give me the oneness as I sit by myself beyond the satisfaction of any desire.

SEVERAL IDENTICAL DREAMS

A certain judge is trying to nullify the title which was given me by Muhammad through the dreams of many good and noble people here in Balkh on a single night. *The King of Gnosis.*

I spoke with God about this. This judge has several ulterior motives. He's like a man with secret lust. He can't help but look at the woman, but he doesn't want to be *seen* looking. This judge is after certain properties, and also he wants to dissolve my prominence. What kind of an Islamic jurist is he that he can't see his own motives? His freedom and authority to decide issues should be taken away. If someone were to enter his house and steal the silver, he would prosecute with a thousand indictments, and if he lost the case, he'd say that Islam had dried up and blown away.

Our dearest carriers of spirit had identical dreams of a radiant old man standing on a height calling to me, *Sultan ul-Ulema,* King of Those Who Know, come out and let the world enjoy your light. You have been neglected too long. Come out.

There is a Marvesi eunuch who serves several families here. He has told me that he heard members of those families telling their dreams in which the prophet gave me this title. How is it possible to *nullify* such spontaneous revelation? By what authority? The servant says he himself saw a large assembly shouting, Blessed are the friends of Bahauddin, Sultan of the Learned. Does it not follow that the enemies will be cursed? God knows and will accomplish what is best.

1:190

HIGH WELL-BEING

Blessings come easily and unasked for to those in a state of high well-being, but when we hurt and grow confused, we must *ask* for benediction.

I will act in such a way that my whole body receives the paradise of desire and the nymphs who enjoy it.

Creation needs no tools or instruments to do its work. Events and objects appear and disappear in silence, with no command and no objection. A wheat seed softens and disintegrates. Then a sprout shows and a new plant begins. Trees and fruit regenerate like this too. Now consider your life, how your prayers go up blank and withered toward the wonder of restored pleasure.

CITIES AND BLESSED DARK

Earth is a wide bed (78:6) where you rest as kings in your bodies, in your faces, where the mountains hold you steady and strong like wooden pegs.

We have given you cities so you may live delighted in pairs, in friendship, and we have made night a covering (78:10) under which you wait for the moment we will take you from its blessed dark to another.

BLIND TRUST

I am feeling the qualities of God, the compassion especially. I want this always.

Reply: *Pay more attention to those who carry my love into the anterooms of your being.*

I do observe those porters of grace. They are like the intelligence that carries the recognition of pleasure to every part of my body. But I want to feel you more directly.

Watch the kings who reveal my glory. You see only the appearance, not the inner work.

I feel a further answer coming: *Give yourself in the way seeds get planted. Disappear in the ground, no trace, as a tree begins to grow with branches that reach their blind trust into the air. Great multiples grow from trusting.*

MOSQUITOES

I was reading the beautiful sura beginning, I take refuge with
the Lord of the dawn (113:1). It makes me want to weep for
the Turkish man who works through his day with such anger
for me. There *is* a darkness spreading enmity (113:3). A blank,
unconscious night-man, drunk and bent on *not* taking refuge
with any Lord of creation-light. I fear the reckless appeal and
sway of that one.

In the clear ocean of dawnlight we may meet a crocodile
or a seal as friendly as the family dog. We may find a pearl or
an empty shell. As the day builds and subsides, both outcomes
are possible.

Someone asks, Why does God cause one way to prosper
and then another? I answer, We cannot know or interfere
with that. We know only that there is a path we go on as we
say, *All praise to God.* This is the extent of the planning we do.

Events and motivations will sort out as they must. A herd
spreads over a field during the day and gathers back together
in the evening. As mosquitoes go their haphazard and busy
courses back to a standing-water nest, so you and I also are
being drawn to return (4:87).

STEADINESS

Soul guides and prophets have an innate innocence, but they
are subject to the same consequences as everyone. If a donkey
veers off-course, he will be hit with a stick. If you do wrong,

you will be punished. Abu Bakr said that steadiness is the central virtue. From the mind's stability comes right action which in turn balances the intelligence.

They asked me why prophets were given hardship. I said it helps to have clear indications. And I added silently to myself, Be more humble like someone held captive. Bow to the one who can free you.

> Well beyond the reach of its fragrance,
> I try to remember and say this longing.

1:210–211

MASSIVE ROOT SYSTEM

Someone asked about the *fear of God*. That fear is your prayer for refuge. Other fears are different. That fear is where you know your frailty, like the thin branches of a tree that has a huge trunk and a massive root system.

God tells Moses to take up the serpent-staff without fear (20:21). I ask for shelter for my fears of sickness, of death, depression, for my fears of tameness, ugliness, and lack of desire. Change them to beauty and passion. Let nothing come between you and me, not even children or family. Let my seeing be without veil (83:15).

Why do we sit here afraid of death, fussing with trivia? Friends, we must not be so preoccupied. Instead, let us bow together inside the trembling that is a calling out to the great trunk and roots of refuge.

EVERY INVIGORATION

My prayer to the mystery is this, Create in me a variety of ways to desire you, and make the implications of each clear, so that all parts of my body can participate in the wonder. And I pray that my search for God be made more energetic, as when other desires come over me, brightening the light in my eyes, and my hearing. Everything gets keener. Give me the wings of more powerful urges. As their wings serve the birds, let my wanting serve this longing. Will I see you with my eyes in the visible world, or know you another way in the invisible?

The answer comes: *Your bones and skin, your organs, your whole body structure is alive with* your *presence. You, Bahauddin, are present in every extremity, in the throb of your heart, your brain, the chest wall. You continuously flood through each section. Those parts do not see you, yet you are as surely in those as We inhabit each component part of the world, the changes in temperature, every invigoration you feel, the slightest delight. Each comes directly from this presence.*

I continued this conversation. So each person knows you according to what has happened in their lives, the losses as well as the great joy. I will now try to guide myself with three motions: one for *praise* to the glory; the second out of my *longing* and love for mystery; and the third, within the gratitude of moving toward a refuge. These three and only these will be the core of my identity as it moves through events with scattered, moiling thoughts, each of them carrying something of these three devotions, to praise and love and find the shelter of your presence.

FOUR BIRDS

Abraham said, Lord, show me how you give life to the dead. Do you not believe? Yes, but satisfy my heart's way of knowing (2:260).

Four birds live in every human body. Each night they're killed and the four bodies mix. Every morning they revive and are put in separate cages. The duck of urgency and greed, the rooster of orgasm whose cry reaches even to the highest tribunal, the ornamental peacock who struts to be admired, and the crow who wants his cawing heard everywhere.

You ask how the Lord revives dead ones, but you're always trying to make vital beings less alive. God is where beings live. This ground we walk is the field of death.

God says, I give life to particles. I make birds fly apart, then come together as a flock. Begin your search for the divine, and warm flower petals will fall and slide over your face and wash the chill from it.

Some think the moth is mistaken when it suicidally throws itself into the flame. Does it not see the moth-fragment remains at the candle's foot? This is how it is: Parts of the world are limned with fire; people feed themselves into the flames. After that, there are some who appear to be burned to a crisp but are actually calm and glowing within.

> Love is hiding inside this rest,
> the secret of love like a falcon
> mewed in the falconer's hood.
> When that candle ignites,
> thousands of lovers burn up.

THE ONLY BUYER

God buys the essence you offer in exchange for the Garden of Eden (9:111).

I buy your kindness, your unselfish impulses, not those around you. Did you expect *them* to be interested? Do you want *two* buyers, myself *and* others? Whatever you do to be popular is a waste of time. They see, then turn away. Does that make you sad? Don't be. I am the only buyer you will ever have.

DIGNITY AND CHOICE

By the One who set the earth with rivers pouring through in mist below the mountains, and two oceans with a strip of land between (27:61), we move the elements into various shapes without their consent, but human beings, unlike the water and trees, have a choice. They are given dignity, discernment, and the evolutionary wisdom that can move from death to new life, again to die and be restored on another level of existence. You have many choices about the ways you live and work and change and survive. Say you fall into an ocean. You may give up and sink, or you may try to swim to shore. Salvation is your decision.

A WILD MADMAN-LOVER

As I was saying *Allahu Akbar,* God is great, a truth came. The continents and the oceans, and whatever lives and happens in or on them, all are held inside that presence. If those beings and events should disappear, God will be visible.

My prayer is: Give me such a craving for pastures, for the greenery beside a fast-moving creek, that straw and piles of rubbish will look like fresh vegetables. Fill me so with bright enthusiasm that any street person will seem like an angel coming toward me.

Make me hungry enough so a crust of millet bread will taste like fine pastry. This is all one prayer: Give me the same longing that drives a wild madman-lover out to look for what cannot be found.

That naked need lives in me as a certainty where I know that whatever I've done wrong is covered by the larger compassion we move inside. That is the meaning of *Allahu Akbar.*

MOTION AND STILLNESS

I was considering the atrocity committed by Haji Seddiq. But why should I mention that to God, since whatever happens, happens by the will and in the presence, no matter what it is, the actions of Haji Seddiq or my suffering them. They're the same.

Revelation: I provide relief when you read the Qur'an and through this open lamenting. Thousands come like you to my

gate to cry out their pain. If they were not being helped, would they keep coming? Isn't my name *Allah?* The meaning of that name is a haven from injustice and disaster. Take refuge from your grief and return whenever you must. If there were no relief inside my name, it would be canceled and forgotten. And not only healing comes there, but great treasure and reward, the seven tiers. (71:15)

I answered, We do not see these seven heavens. We can't know what they're like. You don't show us, so we can't see them, or know our source, or our destiny. We are not being shown this progress of celestial phases, so what is it you offer us exactly?

This was painful, my soul's wanting to slip out of my body to see the wonders of God. But feeling the passage through the densities of creation, through death and divine wisdom, would be exhausting. I said, I'll stay where I am. I feel near the presence here, and I can see the light and the qualities. As I said that, I saw more light and gardens of blooms opening into ravishment and full dissolve.

My soul has two conditions, of motion and of stillness. The moving fills with the energy of a love and tenderness actively overflowing and approaching God. The still condition is for resting when I am tired. There I fill with peace, content and contained within non-activity, settling in, loving the quiet.

I say this to myself alone: When you feel crushed, those around you look broken. When you glow, darkness turns to black light. If you hurt, even the comforts you are offered wound you. As you prosper, your failures prove to be just the right thing, perfect.

OGHOL THE FOOL

Work as you ought to, being God's worker, for the compensation to come. (22:78)

I said to Oghol, the fool, to whom everything is a cause for joking, Sell your vegetables more quietly, so people will not expect this clown act from you and resent it when you don't perform. That way you can live more simply and sincerely.

Wash your bowl completely clean, says a Hindu master, *if you want more food put in it.*

ISLAM IS FOR FINDING FRIENDS

The religion of Islam is for finding friends, the joy that companions feel. One person with another is happier than one alone, no doubt of that. We love to have someone to tell our grief to, what's hurting at the moment, and just to talk with, idle conversation. All this business about buying properties and building structures has at its core the desire to share it with a friend, or many friends. It would take some kind of holy hermit to enjoy the look of the land and the open afternoon sky with only God.

I have heard that the king has said that Afzal must be given a thousand dinars a year to come to this town, the way they do in Bamiyan. Nobody gives me a loaf of bread, but Afzal gets a thousand dinars. Consider his status with the people and then consider mine.

Just as I say this, revelation comes: You are on the prophets' path. No prophet was ever given a stipend. On the contrary, they had great forces opposing them. They received no aid to help them study medicine or astronomy or philosophy. Unsponsored, without father or mother or family, they prayed for God to keep them in the difficult line of transmission. Many people now *claim* to want that.

> Unworthy to wear your grief, my eyes
> become these simple porters who carry
> the trust I have in you and loyalty.

1:245–247

FALL WHEREVER I FALL

When my servants ask you about me, I am near, listening to them. Let them also listen to me when I call. (2:186)

This passage connects with our conversation, the questions we put and the answers that come. One desert wind brings doubt. Another inspires hope and confidence. There is always call and response.

An atheist asks, Where is God? Show me the place.

A ridiculous demand. Place does not apply to the creation done with the divine presence. Location is *not* a quality of God.

Zayn Zarawiye says that the Friday mosque meeting in Herat cannot contain all who want to gather with Fakhr-e Razi. He describes the people going in holding candles. The king has ordered that one of his aides should dress in a gold belt and a silver cap and sit each night in a place close to the pulpit. Whoever points a prayer rug toward Mecca will be blessed.

Then there's Abu Hanifeh who leads them on the obedient path, reading the Qur'an and poetry and old sayings. Qazi Abu Said is praised for quoting 2:37 about Adam getting inspired words from God. Sultan Oulia says the Jews came to Muhammad Ali to ask him to read the Torah.

I hear these things and realize I am much below their standards. I'll not stand and talk before people any longer. I'll fall wherever I fall, get up and go on, not shying from any disgrace. I am a clod in a field that is being plowed, moving with very small motions.

Lines from scripture occur. When the inevitable comes to pass . . . (56:1). The mountains shall crumble to tiny particles (56:5). Dust blowing about . . . (56:6). You shall be sorted into three classes (56:7). The blessed companions of the right hand . . . (56:8). And those foremost will be nearest (56:10–11).

These lines seem meaningless to me. Then an answer to my confusion comes, *In this state say the zikr.*

1:253–254

THE COMPANY OF OTHER GOODNESSES

I ate too much, so I did not feel like praying or preaching.

I said to God, I eat food to stay strong and not lose the pleasures of communion with you, but I have not yet gotten the amounts right. How *much* should I eat to retain enthusiasm and not slip into this torpor?

Sometimes a grief claims me and closes me in a kind of shy self-absorption.

There are lines of sacred poetry that say if the objective is valid, you should take the path all the way to the end and not mind the suffering. If the goal, though, is not true, you will be wasting time, no matter what comes of your effort. It's like you're turning gold into copper. Everybody loses.

Good projects succeed in the company of other good-nesses. If you pass through a cloud of soot, you will feel the grime descend. As you walk the orchard musk, you feel absorbed in fragrance.

This world is an open sky and also a dustbin, giving life to some and death to others; the outcomes are not controlled by this world.

Press your finger into the world and put it to your nose. You may smell sweetness, or you may smell dung. Discernment is possible in these matters.

True hearts stay awake if love is possible. The others have no need for beauty, nor hope of it. If you are holding gold in your hand, don't imagine ways to turn it into mud.

1:261–262

THROW IT TO THE THIEVES

The fear of the Lord is different from other trepidation. You need a healthy fear of what is dangerous before you can reach to the fear of the Lord. Many never reach. You may be like a very slight, limber branch. You look weak, but the wet center connects with a taproot. Hold there and fear not (20:21). Moses trembled, but he was sound to the core.

They said to the people, A great army has gathered

against you. You should be afraid. But that increased their faith. They replied, God is our sufficient guardian (3:173).

Overly cautious merchants do not prosper because of their fear of loss. Brave merchants get broken ten times in a row, then rise at the end. Whatever you fear losing, throw it to the thieves following your caravan, especially if it's your faith.

Whatever you deeply love, give time to that, and if you're drawn away, come back as soon as you can. There may even be a conflict sometime between what you love, your faith, and protecting your children. Stay with what is most in harmony with the love, and the other will fade.

Fear has two forms. One is a worry about whether the effort is *worth* it. People caught in this bottleneck between yes and no stay tortured and confused. The second form of fear is for whether you will ever be able to make it to what you love. Let that one dissolve. Keep moving in the adored direction, and unless you're shown it is *absolutely* impossible, continue going there.

<div align="right">1:263</div>

HERE WE SIT

One man works for several different people who are continuously disagreeing. Another works for one man only. Compare the quality of their lives. (39:29)

I might put it this way. You overload your boat so much that it rests firmly on the bottom at the dock. It won't be going anywhere.

You have so many projects that you have to lie down and rest. You are taking careful inventory of a cargo with no destination. The difficulty of your work is ridiculous.

You say, *But I'm doing this for my beautiful children and their children, for this culture of shops and villages, for civilization.* Grand purposes. Those are like pictures on embroidered screens that you set up to keep from seeing the landscape itself. Remove the images, as they will surely be removed someday. Look *through* your prestigious position and your progeny.

So here we sit, buried in detail, concerned about winning some game, fearful we're about to die. These are trivia and cheap magic tricks. Do you remember the story of Solomon loading provisions in a boat to go out on the ocean to feed a whale? He was helping us see how unnecessary our *planning* is, this proposed agenda we argue the dimensions of.

1:264–265

THE PRAISE-PLACE

God puts forth a parable, a story like a healthy tree (14:24). There are toxic words that burn the skin, and there are good words like the shade and fruit of a parable tree that make the heart glad.

You disciples and apostles, you all do the same work, yet you try to determine who's above and who's below. Each of you thinks you're special, and in that vanity you irritate each other mightily. You think there will not be enough, so you fight for *your* portion like dogs in the street.

Being in harmony is the true way, not this itch of greed, this constricted stall where you and other donkeys get beaten

with a stick. Move instead to the praise-place, inside the mystery, where prayer is unlimited, and you feel the delight of giving homage.

Someone asks why God gives wisdom, then takes it away. I say it's the same thing we do with children, telling them more than they can absorb, then taking it back. It's like riverwater and duststorms that bring benefits even as they flood and scour. Then they subside, and we're left with the damage.

WE MAY BE LYING

There are those who divide themselves and others into sectarian, argumentative groups. You are not with any of those. This will be made clear. (6:159)

Your desire, whatever holds your interest for a time, is like a wind, a flying horse that carries you then lets you drop. You have no control over when that happens or where you will land when it does.

Religion, faith, your "surrender," these are ways of claiming that you live on land and are not anymore endangered by whirlpools or by the waves that lift a ship and slam it down.

Anyone who says the sentence, *I have faith,* may be lying in either or both of two ways: his real dependence may be in how he enjoys pleasures, or in a treasured bitterness about suffering.

Remember and be warned by the couplet,

Your eyes are my religion,
this dark hair, my faith.

Call on *Allah,* the compassionate presence (17:10). Inside that crying out, your life has majesty, no matter what happens. The craftsmanship that builds cities with their slender minarets comes as a gift from there, as also do the mountains lifting, the tremendous spreading air. (51:47)

WHY DON'T WE CRY

Someone asked, When Abbas, the King of Ethiopia, and Omar heard even one miraculously given verse of the Qur'an, they wept. They wept, yet we recite whole chapters, the entire book, and remain unmoved. Why don't we cry? Even those stone animal images in the clairvoyant woman's shrine wept when the fiery presence of the young Muhammad came near. Maybe there is some ugliness about being apart from the Friend that we don't see, some sharp longing we don't feel. Maybe life-troubles have dried us out so that when God's love-fire comes, we don't weep as wet limbs in the heat let go their sap. We turn instead to gray ash. Is it the world-ambition called greed that makes us numb?

Lovers stay on love's way even when their families are torn and eaten by lions and tigers. Everything gets taken away, but still the presence of the Lord sustains these beings and lets them flourish.

OUT LOOKING FOR PLEASURE

Whatever state you're in, remember you are *inside* the presence. Out looking for pleasure, there especially—I have found no delight better than the mix of touch with love. That taste is the sweetest. When you are tranced in that, recall who gave you these pleasurable forms and inclinations. Even when having a brain seizure, remember how earthquake energy pries apart mountains and zigzags a stone wall. Let that core-energy break your convulsion.

When you're afraid of a certain man in power, of some authority binding you, in those anxieties, as well as in full prostration prayer, taste the presence.

The children's dear innocence rises from the confused muddle of our desire, as crushed mint and calligraphy around the edges decorate our homage. How we love *and lust* praise the infusion of shapes with light.

CLEAR FOR ME THE *ME*

I have lost the central thread of my awareness. Limping in this uncertain air, I pray for God to do whatever God does. But which *I* of *me* is asking? There are many, some wavering, some solid. This prayer is, Please clear for me the *me* that wants your presence.

But that goes again to the problem of dividing the indivisible, which is beyond existence. Infinite particles scattering against and through each other: I am this heaving breakage.

Help me feel each breath as the last prayer. My children are orphaned, my body settles into dust; the akashic records are full of my sinning. There are no more life-chances for me. Do what you will with this I am, you that are both rose garden and a field of thorns on fire, you that have told us that inside you the mystery of forgiveness overrules the truth of judgment.

1:278–279

SERIOUS COURTSHIP

A convening of scholars decided to do something more exciting than their scholarship. Let's bring some unmarried women here and talk with them.

One particularly ugly older man among them was smitten by the daughter of the king. No one else would do for him but the princess. Have your party, he said. I have other plans.

He went under the window of the princess and mumbled his prayer. Finally she noticed. I can't hear a thing he's saying. She told her servant, See if he has a message for me. Ask what he's afraid of. Of course, if he offends me, he might lose his head. That's just how it is. The old man listened to the servant, gave a loud cry, and fell down dead.

Show the way (1:6) means, Ask me to show you the way to me. I answer, Show me the way anywhere. I'm content with any direction from you.

A man loved a woman. He asked her to meet him at night. She finished doing her wash and came, but he had fallen asleep. She put three walnuts in his pocket and left. The man woke and understood her sign. You are still a child, not a

lover. Play with these walnuts. Roll them along the ground. A lover is willing to sacrifice anything, life, waking, sleep, a sense of self. True lovers give these up easily for a chance to be with the Friend.

WHY SUFIS WEAR GRAVECLOTHES

1:293–294

As constellations bless the nightsky (25:61), we live in a house whose interior illuminates, with outside a dark roof. This bright within pitchblack is the truth and why Sufis wear graveclothes outermost, so they won't seem self-absorbed. We're dead, they call out to the street. We have no part in anything happening here, yet every grief is ours.

IF THERE IS NO JOSEPH

1:295

I will have sweet patience (12:83). Bright flames inside make a soft glow without. Enlightenment knows how laughter hides inside grief. Only if you love can you feel absence.

If there is no Joseph for you, you're not alive. Jacob felt so happy with his son that his crying out for the stain-colored coat still breaks everyone's heart.

JACOB

I will have sweet patience (12:83). Calm exteriors, burning within. Where is a lucid person who can look with me into this field full of secret-keepers, with their pleasant laughter and polite smiling? Inside they are weeping and moaning. Very few cry their grief openly.

A great depth comes when one gets separated from the Friend. Only then is a human being tragically alive. If there is no Joseph, Jacob is never really Jacob. Unless you have spent some time in a garden with your beloved and then been pulled apart, your life will not have passion or vivid depth like a story told in scripture.

Everything has an opposite. When you love one thing, you hate the reverse. Another truth is that with any situation there is always a better one just above it. This proceeds upward until it reaches the divine, which is all around you but you do not see it. Expand your vision and you will. Live inside the story of Joseph and Jacob. Sit and beg to see God. Plead like the prophets. It is your birthright to be shown and *see* the divine.

WAYS OF KNOWING THE UNSEEN

Mahmud Abdulrazzaq prayed for three nights to be allowed to see Muhammad. Instead, he saw Bahauddin. Abdullah Hindi also dreamed of Bahauddin on a throne with servants carrying golden flags and people taking the ablution water he

had washed his feet in to rub on their faces as protection against invisible threats.

The sister of Turknaz claims she saw the prophet in a waking state, and other visions too. Such experiences are stronger than the knowledge that comes through education. The one who gave you senses to take in and absorb the world also gives ways of knowing the unseen.

1:304–305

TAKE NO CREDIT

Devout believers, stay near other believers. Those others, in their hearts, want only disaster for you. We have given you signs to make this clear (3:118).

With genuine believers your heart is full of compassion for them and love for the prophets and the angels. You will be rewarded in the unseen for this. If God gives you wealth, share some of it with those in service. If God has not blessed you in this way, relax. Don't worry about it.

Whether or not you fight is your decision. If you do not use force, there will be no fighting. Whereas, if you have no sexual desire, you are dead, and if you have too much, you'll be shattered to smithereens like thin glass in a blast of wind. The more work you do, the more power builds inside you. Profit depends on expenditures. *No strength but yours . . .*

There are two ways of working. One flows from your heart, the essence there and its connection with the divine. Another way caters to body-desires, those satisfactions. A clear division exists between what pleases the heart and what answers the call of the *nafs,* the urgent body-wantings. Help

us hear those for what they are, and help us to take no credit for the heartwork we do. Let us forget and be blind to our own virtues. God protect us from self-adulation.

1:310

FRIENDSHIP BRINGS BEAUTY INTO YOUR LIFE

It is the depth and vibrancy of friendship that brings beauty to your life. Friendship is the ground you plant your tree in, the fertile basis of your flourishing. Friendship creates a continuous vitality around you, and in you. The friend may be a bird, or a cat, or a frail person who is dying. Still, if the friendship is strong, it will purify the circle of your living as a drop of the prophet's blood does the ground it falls on.

True friends sacrifice wealth and reputation, everything, for each other. When asked why, they say, *I wish I had more to give.* Abu Bakr and the other companions of Muhammad lived in such a friendship.

1:315–316

WHITE-BIRD SENTENCES

In my dream large white birds, larger than geese, were flying. As they flew, they were praising. I understood the bird-language. One was saying, *I praise you in all circumstances,* and another was saying the same in other words, and another in yet other phrasing, but I could not remember what I should

say. I interpret this dream to be telling me to be continuously grateful, no matter what, in my waking life, and also to remember that there are a hundred thousand ways to praise.

These white-bird sentences begin in nonexistence, where creation makes entity from nonentity. What flows through us as praise comes from where Moses and Jesus are standing with the other friends of God.

Another night in the state between waking and sleep I saw a gazelle coming toward me with an open mouth. It put my whole head in its mouth and turned its lips in arcs around my forehead and chin and the sides of my head. The gazelle-maw got larger and larger. It could have swallowed my whole body. About to lose consciousness, I began to chant, *No power but yours, no power but yours.* . . . The strange malevolence that was trying to devour me went away. Peace came. Now I know how epileptics feel.

In another dream I was eating salty food. My gums became brackish. I woke with a salt taste in my mouth. Events happen here that no one records. Universes overlap. We are led in ways we will never understand. It should not surprise anyone when the angel Gabriel comes and takes Muhammad away in an instant.

Someone asked, If the commands of God are preeminent, then what choice do we really have in life? Between the words *preeminent* and *commands* lies a great mystery. The divine essence is not *like* anything, nor can we examine it or its effects. Try to trace to a source *just one thing* that has ever come to you. Now imagine you are blind from birth and that you have never seen this world or recognized any of its meanings.

THE SPECIAL STRENGTH
OF MUHAMMAD'S LINEAGE

I was reading the Qur'an when suddenly a great fire rose up. Where does such spontaneous flame come from? What elements have to be mixed or just the right distance apart for combustion to occur in this place at this time? We know that pressing one body against another can lead to sexual desire. In the cold and wet, the excitement of heated agitation brings results. I ponder these matters and see that every creature and shape moves in a huge alchemy of helpfulness. It is like a great multicolored, intricate being-form that when you push one edge, every other part responds. Or like a medallioned carpet with another equally complex moving beneath it, with their translucent designs creating other patterns and the blending colors playing deep inside those.

Or say this world is a dancing Sufi, his hands moving one way, his head in another rhythm, his feet and knees syncopating between, with all the parts held in one mad, magisterial presence, skin, hair, eyes, voice, song: this world's restless changing. And my soul is a pliable mould that empties and takes different shapes, which fill and push against one another, spill and transform, and go on. These hands and feet do not reach and step of their own volition. Something larger within and around moves through them.

My mother insists that each great sheikh receives his greatness from his mother. But consider this, Mother. When I do something wrong, you shout at me that I was responsible for that. Then when I do something right, I must also be responsible, because then you do *not* shout at me.

~ ~ ~

I have tried to learn about the goddesses of India. Yasimin tells me that the followers offer the devas gold and jewelry and that there's a great competition as to who will give the most elegant gift. The goddesses protect their devotees' property and attend to their requests. For example, one might go to a particular temple and fast for ten days, or twenty, asking that a certain matter be resolved. Semi-conscious from hunger and thirst, the supplicant might then hear in a trance the deva saying that his wish is granted, or that it will be in ten days, or twenty, or not at all. When he gets such an answer, he must leave the temple area, or the likeness of the goddess will come in his sleep and slap his face. Not the actual statue, but miraculous events do happen in such belief-charged situations. Yasimin says that if someone from outside, say a Turk, were to enter one of these temples intending to harm the goddess, he would not be able to find his way out; he would wander the darkness and go blind.

Once in a dream I sat with the great Sayyid Nasabeh. Then we went walking in our friendship, and when I woke, I felt filled with energy and strong desire. I recalled then that Muhammad was given unusual vigor for sexual intercourse, and that his *baraka* (the many forms of energy and divine presence coming through him) descended through his followers as well as through his family. This lineage of believing carries in it the special strength and potency *(mojame't)* of the prophet.

A BRIDGE CALLED *SARAAT*

They asked me what constitutes blasphemy. How can one be unfaithful to God? I say it is when there is perfect light and yet you still see darkness; when you are surrounded by miracles and yet claim partial responsibility and reserve final judgment; when you refuse the vision and insight given you.

There is a bridge called *Saraat* reaching from the seen to the unseen, less than a hairsbreadth wide, yet every living thing could pass over it. Some people cross quickly and happily, laughing. Others are quiet and take their time. The unfaithful are those who consider they might actually *be* the bridge.

As mortal suffering and delight are true, so too are the joys and afflictions that come to spirit. Imagine in the ground the place where earth's progeny get torn apart and reduced to particles. From there one can see pure color, worlds of being and nonbeing diving into each other, small scenes that open like morning glories into the light of the kingdom, which is many times brighter than the sun. I know this because it has appeared to my eyes.

Remember how Muhammad's soul flew out through his lips. Souls *do* leave like arrows from the body's bow. Some go true, some careless and unintentional.

Friday morning I woke with a choice to make: to follow the prophets or to follow the learned ones with their jurisprudence, and homilies, and carefully considered cultural observations. I chose the prophetic line. I assume I was divinely led to do so. I will help others to join with the being and knowing of Muhammad, who understands how lives should go much better than I.

Then I became confused again as I remembered what happened to the prophets. John the Baptist decapitated, Jesus crucified, Noah ignored. Abu Bakr's terrible toothache, the suffering endured by Job's mother and Vis,[25] Abu Jahl's taunting of Muhammad. I do not feel able to make the daring pronouncements of John the Baptist or of his father, Zakariya.

Then I took this thinking further. Everything that happens, good or bad, virtuous, degraded, all events occur inside the divine will. Every prophet ends in glory. It doesn't matter whether you're early in your life or late: draw close to the presence, and you will become something better. Enter the mosque on Thursday and Friday. Pray, and wish that your wish is moving with the will of the whole that created you (6:102) and continues to make what you make (37:96).

[25]Vis is a character in an ancient Iranian poem, *Vis-e Ramin*. See Vladimir Minorsky, *Vis o Ramin, A Parthian Romance* (Cambridge: BSOAS, 1946), pp. 741–763.

THE DAUGHTER OF JUDGE SHARAF AND I ONE MORNING

I have wondered what the nymphs of paradise, "the white ones," will be like. Maybe like the morning I lay with the daughter of Judge Sharaf. I gently bit her lip as I held her. She's a beautiful young woman, but her skirt had blown up over her waist as though she were a child playing.

She kept whispering in my ear, *Oh God, God,* calling to the same one who gave us the pleasure of our bodies as they were moving together. I was kissing and breathing her breath in and out in a delightful wave of orgasm.

The Qur'an says, They will recline on couches (52:20). So sometimes when we are depressed or in pain, the soul flies free of that sadness to move with desire for a lover. As our body's organs respond to the leaning back that comes with physical ease, reclining into sex also gives the soul freedom.

Two oceans, salt and fresh, wash through one another (55:19). No one knows which is which, suffering or pleasure on the edge, the reef, where pearls and coral take form (55:20).

STAY NEAR THIS DOOR

Who divides up and distributes grace? Why was the Qur'an not sent to some *prominent* man?

Events do not happen the way we want them to, nor should we claim that they do. This is worshiping our own interests, the way the original inhabitants of Mecca did, the

Makiyan, when they denied that Muhammad was a prophet. Why not Mas'ud Thaqafi or Walid bin Mughireh?

God says, Look at the beautiful gift of this world. You easily accept that, but not the one I send my words through? Stay near this door and notice the wonders. The look of faces, the white hair, the black. Any faint flavor you taste comes directly from the presence of God.

1:331–332

WHY SAY AUTUMN

Whatever cold and unconscious act you have done will come back and be done to you (10:27).

If you sneak a look at the private parts of other people, they will sneak looks at yours. Friends, remember in your shops that you live inside this mystery. Don't shortchange or cheat anyone. It's not good business. And don't be hypocritical, using a religious practice to raise your social position. Don't exchange inner peace for some decorative doodad.

The body-prison opens in sleep to world beyond world. The six directions compose one of our homes. There are others.

> The soul's eye sees an image,
> then comes a desire to act.
> Why say autumn is the end of loving?
> For us there will be another spring.

57

GREAT CHANGES IN ME
I CANNOT DESCRIBE

I told the local astrologer that the fact that he doesn't see something doesn't mean it doesn't exist. A lover may perceive a certain light in the beloved's face that another person can't. A healthy person tastes a variety of flavorings in food that a patient with a coated tongue cannot. To the sick everything tastes bitter.

Great changes and shifts occur in me that I cannot describe, but they are very real. Ways open. A fragrance from the divine comes through. No one sees this, but it is the most profound event in my life. Friendship cannot be seen or measured, but the experience of living within it is beyond argument. Words like *belief, righteousness,* and *faith* can be used however a debater wants. With Hasan the silk-weaver recently I spoke of the power of the Islamic prophets. Then he used my words to support his free-thinking lineage.

Soul comes here from the unseen to observe this world, the body, the night, and the sunlit morning landscape, saying, I have seen this; now show me your other properties, Lord of the universes (3:26).

THE SUN IS A MOTH

An eminent jurist asked me to explain what an enlightened being is.

Someone so aware of depth and mystery that he or she doesn't consider paradise or hell, usury or the prohibition

against wine, this life or the possible resurrection. Such matters do not occur to a gnostic master, who simply knows himself or herself and says nothing of presence, whose soul is the wine of wisdom gone mad.

A candle has been lit inside me
for which the sun is a moth.

SPIRIT-RATIONALITY

Abraham was tested with certain commands. He came through those ordeals as a leader of his people. We create faces which cannot be seen. The human soul, like every spirit-being, is unknowable by the five senses. Soul-essence cannot be seen, touched, smelled, tasted, or heard. But still these unperceivable beings do communicate with each other, and they have their own rationality beyond what is empirically provable. Among themselves they know which are dangerous and which benign. Sometimes to discover the talents and limitations, an inaudible command shoots out toward one of them like a tongue of flame. Abraham survived such a moment and was invited to lead the prayers.

BEING TAKEN

When you begin to surrender, forget yourself. Become senseless with no motive, so you can be blown from east to west and back without knowing anything, or caring either. It would not be surprising if in such mindlessness your essential being went hundreds of miles without you being aware of it.

We see such wandering in the clouds and the waters. The forests and the crops too in their ways travel with caravans of people along the earth. God takes our souls on journeys we know nothing of. Why? We don't know, being as we are the passed-out reveler laid in a wagon and driven elsewhere. What we love, what we want, is this being held in the presence, this being *taken*. That is the satisfaction, not learning why or how or where we are, or when we'll arrive somewhere else.

Hindus have a belief system explaining these mysteries, ideas about resurrection and other realms swarming with dragons, snakes, scorpions, elephants, monkeys, and combination human-animals. They figure the image of a thief with his head in the mouth of a dragon will frighten people enough to keep them from stealing.

I am coming up on fifty-five the first day of this next Ramadan, twelve hundred and something. With the average lifespan between sixty and seventy depending on one's vitality, I figure I have ten years left, three thousand six hundred and fifty days. What shall I do with each of them? I have not yet found a better way than by celebrating this mystery that is carrying me along without my knowing, the one I talk to as I say, *No reality but you, only you.*

CUT CORDS

My body felt so weak and broken, I thought that unless inter-
vention came from a divine agency, I would not survive. Any
movement seemed impossible. It occurred to me then that if I
were a tree in a town with many trees along the streets, I
might revive. Trees thrive in the company of other trees. But
probably not. No life was flowing in me. I would just be a big
dead urban tree.

Then I felt as though I had set out toward a certain town,
then gone to another, then back to the first, to yet another,
then returned to where I had started, all for no reason, with
no benefit, no joy, and no delight in the traveling that came
from no inward prompting.

Human beings are suspended lanterns, lights living in the
air. The cords that hold them taut are motivations. When
those are cut, the lanterns fall, dim, and go out. People lie on
the ground, sluggish and sideways. The soul is another kind
of cord connecting vertically with the divine. Changes come
into us through that conduit, and also powerful impulses to
move.

Wisdom brings a wholeness which understands its own
ignorance. Someone with a little knowledge denies this, but
those who study their lives long and diligently *know* they do
not know *anything*.

THE SPRING OF MY SOUL

As for those who are generous and know the refuge of the presence, we shall make their path smooth (92:5–7). Difficulties will dissolve, and you will be able to observe the wonders and those only. You will discover many ways, and they all will be clear and open to you.

Once again I look into my soul and see that it is a warm spring with the presence filling every drop and that each is unique with a way that is only its own. I see the entire world like this spring of my soul. The whole universe too. One source, and then the branchings from that, and other fluid tangents from those, and from those each ramifying thread-drop becoming itself alone.

The flowers so various, the red jasmine, yellow, iris blue, lavender, trilliums with every moment new color variants, new petals. This is God reviving, revising creation. One must contemplate the meanings of the continuously new details in themselves and as grace and healing.

Consider also the meaning of light. Of violence and separation. Of grief and the pleasure of sex. All these are gifts to us, but sexual delight and looking into a beautiful face seem to come *directly* from God to the human soul. Even in the midst of the trance of such pleasure we should remember the giver.

As for those who choose to remain outside the presence, it really doesn't matter whether you warn them or not. They are determined to stay apart (2:6). They are behind a curtain by our command and their choosing. The wall in front of them is made of their bodies. You cannot know who is behind the curtain. You can only stand out of sight and call to your friends. Those who respond do so according to eternal find-

ings. But it is good for you to call and continue calling. You are like a diver who goes to the bottom and brings up sometimes a pure gem, sometimes an ordinary stone. Your diving does not change one into the other.

As you move through the world, visit the goldmines more than those mining other ore. Your work is not to transform one to the other. Your work is to shake the tree. The soft ripe fruit fall. The hardened ones stay where they are. Everything you do is a helpful service like this. Do not move into work that isn't. There are heretics who claim that the presence appeared *fully* in Adam and that that's why the angels bowed to him, *fully* in Jesus, which caused the dead to be raised, and so on. They say that God appeared fully in Ali to organize the world and support the prophet Muhammad. He is most high (2:255), they quote, meaning when it thunders it is Ali's roar giving rain to the earth. This is like the astrologers who claim the stars are telling them what to do.

1:367

DON'T GO TO OTHERS

There is much weeping when lovers leave each other, whole artforms devoted to parting, but what about when one who has known attention from the mystery grows aloof from that guidance? How sad is that separation? What about someone who dies without ever knowing the presence?

That presence can sometimes take the form of a disaster, a deepened awareness, or something more hidden. It may come when you are sitting quietly at home with your children and your wife, or in the devotion with which you do your work.

Remember to move within and live as close as you can to that, and if you feel yourself moving apart from it, don't go to others for companionship. A child cries until the mother comes. Be that demanding. Listen to music and song until your divine Friendship revives. Listen to those who achingly long for God. Noah was a prophet because he so constantly *feared* losing the closeness.

<div align="right">1:368–369</div>

THE CHAIN OF EVIDENCE

Klave,[26] a wanderer and a watcher, comes to the gate of a town and finds it controlled by a group of mean-looking characters. He decides not to enter the town but rather to go back the way he came.

That will cost you one dinar, they say, *to go back that way.*
I will stay then and see the town.
That will cost you two.
I'll contest the fee.
That will cost you three.
So he pays the two dinars and enters the town to seek justice inside the walls. In the public square a man is cutting off the tail of a bear. There is much commotion and flailing about, so that the man's pregnant wife falls and has a miscarriage.

The wandering man, the crow-commentator on such scenes, continues to the judge's courtroom where a case is

[26]Klave seems to be a kind of Nasruddin observer-participant in the follies of the world.

being tried, a man demanding compensation. His father was working in a house with a precariously hung door, a heavy wooden panel which has fallen on the father and killed him.

The carpenter is called. He says a beautiful young woman was passing by. She distracted him into doing the shoddy work.

The young woman says it was the lady of the house where she works who sent her out on an errand to have a shoe repaired.

The cobbler blames the blacksmith for selling him a tool that did not perform as it should have.

The blacksmith admits the fault does lie with him, but if he is punished, the whole community will suffer. There is only one other blacksmith in town and more than enough work for the two of them. On the other hand, he suggests, there are two launderers in town and not enough laundering work for even one. Following this logic, the judge orders one of the laundry men executed.

Now it's the turn of the cutter of the bear's tail and his un-pregnant wife. With his rationality honed by the former chain of evidence, the judge rules quickly. The tail-less bear shall be awarded to the tail-cutter until such time as it may grow a new tail. Likewise the tail-cutter's wife shall be given to the bear-owner to have sex with until she is found to be pregnant again.

Court is adjourned.

SELF-HELP

In the middle of last night I was considering how I could improve my behavior and make myself more cheerful and pleasant to be with. But really, are such thoughts any different from plans to make more money or gain higher social status? These improvements are all about appearance.

How would it be if everything I did were for God, if all my ambitions were truly for having a clearer sense of the presence that permeates everything? Such midnight thinking gave me a headache. I could not sleep or pray or concentrate on my work.

This came: *Don't think so much about me. Live in the kingdom of love where you walk along most naturally. You are not meant to untangle these theological contortions.*

A certain Sufi from Khwarazm had a mother who was known for her kindness with everyone and everything. She would never do anything to harm a human or an animal. As she was dying, her children gathered around the bed.

Suddenly, she sent them away. *The others are coming, the pure ones.* Her children left the room but stayed hidden close by. There was a slight shiver of her nostrils; she expired. No more breathing, but a brightness bathed her, a light that stayed around her body for a time.

INDIVIDUAL BARGAINS

The living are given homes according to their unique individualities. A nightingale has a familiar place, the turtledove its hidden nest. Crows have different accommodations. Gemstones hold values that road gravel does not. Each being flies toward its home, toward its *value,* on wings of longing, one to be a shoemaker, another, king. Different bargains are struck with each.

Very early one morning I rose and went to the mosque to try and change the bargain made with my soul. Several observations came to me as I did this. One was that early morning is a fine time to be up. The second was that there are places where demons attack people like packs of dogs and other places where the influences are more angelic and helpful. The third was that human beings, men especially, are likely to absorb the demonic qualities and then gather around wealth. We should be wary of rich people. You may not *see* the threat. It's not physical. The damage they do happens in your heart.

MONEY-FRAGRANCE

Sometimes I think of myself as a king with nothing to rule, a judge with no jurisdiction, a minister with no policy to implement, a rich man of no wealth.

Do you catch the pretentious money-fragrance in these thoughts? Do you hear my ambition and envy?

If I could merge my soul in the presence, if I could dissolve completely, these imaginary, self-pitying stories of who I am would go away.

People climb tall ladders toward power and wealth in the marketplace, but each time, before they reach the top, they fall back to the ground.

1:377–379

ISLAM AND MONEY

I got up this morning resolving to follow the way of truth more clearly. But how can I do that when I'm contriving to be in the company of kings and ministers and those who have power to give me more dinars and drachmas? Islam is not about money. Muslims don't worry about livelihood. They worry about the depth of their surrender. The friends of Muhammad never discussed how they would manage to have food and shelter on their pilgrimage. The Qur'an is not a handbook for improving lifestyles.

Moses did not command the Israelites in battle. Muhammad, though, was called upon to be a warrior. There is an exaltation in that demand. A certain fierce firmness is required. Then I felt the sadness of those who doubt and live outside this lineage, and the joy of those who trust. I conclude that Muhammad is the most admirable base for a religion. And just because one does not understand Islamic government does not reduce its brilliance. Fake jewels do not devalue real ones. Everyone has a unique responsibility. If Adam's son sins, don't blame Adam. If some descendant of Ali harms you, don't malign all of Ali's descendants. If one learned man is meanspirited, don't generalize from that about the mind.

THE RETURN MESSAGE

Fasih Valvalji, while delivering a discourse, pulls a letter from the side of his turban. This must be delivered to my master in Bukhara. Who will take it? A dervish immediately jumps up, takes the letter, and leaves. Fasih continues talking, becoming more subtle and eloquent than he has ever been. After an hour he finishes and returns to his home. Someone knocks on his door, saying that he has brought the return message to the Bukhara letter. The doorkeeper brings it, and Fasih reads. *The peace of God, my son. Someone who dares to act openly in this world should use the eye of his heart to distinguish those who mean well from those who want to damage the love-work.* Fasih runs to the door, but the street and the night are empty. The magnificently fresh language of Fasih's discourse earlier also came because of the Sufi's presence with them.

I have observed that the good things I do, as well as the cold, unconscious things, both occur within the presence. With this difference: my good acts are praised, the unconscious ones not. If the soul were to do only as it was clearly led to, every act would be praise. It occurs to me now that there was a time before the prophets, an interval, when people prayed to idols, and being excused for their ignorance, the prayers were granted. Even now in regions of the world where our prophetic lineage is unknown, human petitions are heard and granted. I want to live there, or back then when my ignorance could be forgiven and my separation could serve as a way into union.

WHITE-HOT, RED-ORANGE, ASH

I have watched a brick kiln doing its work. The inside of the top is white. Below that, an area of red, then orange, and below that, black. Anything that moves into fire goes through these color stages. Likewise with the fire of God's love. When someone first moves into that, he or she is sad and bereft, ashen. Then comes the ecstasy of illumination, red-orange. Then the shining obliteration of white-hot. Moses felt these three, as did Muhammad and the prophets.

Someone says he wants to study wisdom. I tell him there are two paths. One is formal and public, where you prepare to give sermons and teach and perhaps make the complicated decisions of a jurist. The other is completely private. No one knows that but the seeker himself (6:59). Such pilgrims are always being directed in secret by the mystery. All they know of this world is what is shown them.

Early morning. My thoughts are interrupted by a dog barking. Then Bibi Alawi walks into my room, dazed, just up from her bed. My desire for her kindles. It occurs to me that all this is grace. The barking interruption, and Bibi Alawi too. Why be ashamed of feeling desire?

A revelation comes: My work is to elevate as well as humiliate. One moment I make someone dear to you; another, despised. So when you feel anxiety, remember God, because the anxiety comes from there. If you feel pain over what is happening to you, pray that it be taken away. If you are delighted and those around you are prospering, ask that this keep happening. However, if your soul is conscious enough to live as I have just said, you are the next prophet.

I was standing next to Haji Seddiq in the prayer line with

these mumblings in my head. I continued, The soul's under-standing is that *everything* comes from the presence. That's how we know God, through the awareness that the soul has. If everyone could know this all the time, everyone would be a prophet. But that is not the case. Prophets have been given the power to renounce tasty food and drink, to relinquish plea-sure in order to dissolve their attention more completely into the divine. Very few can do this. Most of us rejoice in desire, in sex. We relish food, the savor of this world, and we also de-light in the prophetic line and what comes to us through that. We are blessed differently than the prophets.

<div align="right">1:382–383</div>

ARMSPREAD, WINGSPAN

Come together willingly or unwillingly (41:11). Freewill seek-ers open themselves to the sky, while fatalists, for whom ev-erything has already been determined, get driven about like cattle (7:179).[27] To live an illustrious life, you must make deci-sions. You must live your desires as well as your soul. Abu Hanifa is wrong in *Religious Jurisprudence*. To become distin-guished, you must choose to live fully with wives and children and every kind of desiring. Then your soul mixes with other souls and the collective soul can rise to a more lordly vantage. Your memory will expand to include other memories.

[27]The Qur'an does not condemn the Fatalists, who came much later than Muhammad. This passage is a more general condemnation of those who do not understand.

I was looking at my soul. It spread from east to west, open to every action and insight, prophetic, wondering. What if Gabriel has become me? Then I saw my small bodyself and two thoughts came. One: Observers do not usually perceive the tremendous reach of a soul, just the physical armspan. And two: Graves appear bleak and motionless, but in reality the spirits of those buried are more alive than anyone imagines, so glowingly fresh and mobile and sage on their errands.

1:383–384

THE YOUNG WOMAN ON THE STEPS

I was trying to invent a new parable about a person in a difficult job that has only material results, some work with no soulgrowth involved. I thought, an ironworker; a blacksmith pounding in a forge surely has no spiritual purpose. Then I wondered what value to the soul this business is that I do. None I know of.

Someone said once that one who takes no pleasure in desire or in having secular power doesn't really appreciate the gift of this world, where lust and dominion are staples.

Yes, I replied, but there is an infinite variety of pleasures that you're forgetting. When God closes one door, many others open. Angels take delight in ways we can't know. Demons do what pleases them. Each animal has its own strange dance.

One day, feeling lethargic and half-alive, I come upon this scene: A young woman sitting outside on the steps of a building. She is surrounded by young men and totally in command of the moment, teasing each in turn in a way that piques his peculiar personality. Their mouths hang open at the spectacle

of her attraction, and her vitality visibly brightens with their attention.

It occurs to me then that the secret of feeling vibrant may lie in having an audience around that you can tease and flirt with and lead along the way of slowly falling in love with you.

So I prayed, Dear God, you created me. Some of your essence lives inside me. Show yourself as a group of admirers. I will tease you; you will accept my advances. I will pause. You will eagerly wait what comes next. I will invent new stories, and you will listen, rapt with my charisma.

1:393–394

NO FURTHER DELIGHT

How can I explain the other worlds to those who say there's nothing beyond what we touch and see? Materialists quickly reach their limits like a man so stuffed with food he finds everything tasteless. The feeling that there is no further delight comes from ingratitude and a refusal to admit your failures.

1:394–395

OUR ANIMAL ENERGIES
AND OUR BEAUTY

Someone asks about the language of the Qur'an. I say one who has memorized the Arabic without knowing what it means is like someone holding a jar of water without knowing how it tastes. God has given you a favor that guides you

toward truth (49:17). There is no greater grace than that. When one has not entered into the glory of *islam* (submission), he or she must keep working toward it. Someone who loves you may not say it out loud, but you will feel how the seven body centers of that person are there, attentive and available to help you however they can. You have been given beauty, and you have been given animal energies, which provide power and value for the beauty. Your goodness and beauty are *alive* because you have been given a choice, and you chose them.

I was thinking also how I have loved being a Muslim and helping the poor. I say I want victory over infidels, but did not God create them as well as myself? I have no answer to this, so I let the problem go, and move on to more personal worries, which I have an abundance of. For some reason there are many more unbelievers in the world than Muslims. Who knows why? I'll spend my time rather remembering God.

1:396–397

THE SOPHISTS AND ABU HANIFA

A sophist comes to discuss the nature of reality with Abu Hanifa.[28] He ties his camel at the door of the mosque and immediately begins his argument as he is walking toward Abu Hanifa, who gestures secretly to a servant to hide the man's camel. There is no reality to anything. Everything is illusory,

[28] A jurist and theologian (c. 699–767).

dream and mirage. Hours of sophistry later he comes out and looks for his camel. But what you *thought* was your camel may well have been a dog, or that bird. Quick, it's flying away. All so fleeting. So Abu Hanifa teases the sophist toward Islam.

Another time Abu Hanifa meets a sophist on hajj riding a donkey. He orders the man to dismount. Members of the community loosen the pack saddle from the donkey, lift it off, and tie it to the sophist's back. Why are you doing this to me? Since there is no certain reality, Hanifa responds, we cannot be sure whether you are the donkey and this is the man or the other way. So we must alternate positions periodically to accommodate that possibility.

1:402–403

EATING A PIECE OF BREAD

While you are eating a piece of bread, try to recall the events that collaborated to let this take place. The oven's heat that baked the bread, the plowed earth before that, sunlight, rain, harvest, the winnowing, the being carried to and from the mill, the complex idea and the building of the mill itself. The many motions of weather in the turning of four seasons. And don't forget the knife that cuts the bread, the metallurgy and the skill of forging that blade, and your teeth, those original grinding devices. Then there's your stomach digesting the crust and there's the rest of your body being nourished, each part in unique ways. Two hundred and forty-eight bones, five hundred and thirty muscles, three hundred arteries, ligaments, tendons, cartilage, your organs and limbs, your brain. As the bread dissolves, many intelligences within you are

deciding and peacefully agreeing on how to divide the bene-
fits. If there were discord, you would feel pain and cry out,
but you don't.

Now notice the unified human awareness thoughtfully
living inside your body with a soul in communion with other
spirit-intelligences. Observe how it sits at the junction of two
worlds as a human being looking with kindness on other
human beings. Some say this is the culmination of the body's
long development and the beginning of the next transforma-
tion, that you that live with gratitude for food and thankful-
ness also for any difficulty, pain, or sudden disappointment,
seeing those too as grace, that you live inside and outside time
as an angelic breadeating witness taking in this myriad con-
vergence of providential motions and that you are in yourself
an individual soul being made from divine wisdom.

1:404

PROFUSION

I am continuously wondering about creation, how the uni-
verses came to be, and why. Can there ever possibly be a sure
understanding of these things? Now it occurs to me that the
variety of vegetation growing out of the ground is an analogy
for the mystery of creation.

The apple, the onion, wheat, pistachio nuts, thyme, mint,
the peach tree, the cedar, and the grapevine, each grows in
weather and soil that suits it. The same with human beings
and their various capacities. There need to be liaisons with
many different ways of knowing. We need ambition and
horsetrading, carpentry, much drawing-up of house plans,

and knowing where to store ḥarvested fruit, and what to say in the market to sell it.

Every action comes from the source, as the profusion of plant life grows from secrets hidden in the ground. Trees need rainfall and wind to leaf out in spring. People need friends, pleasure, interest in their work, and enough curiosity to keep moving.

Sometimes it's right to dig around a tree and transplant it somewhere else. Sufis advise, *Go where people cannot help but fall in love with you.*

A student of mine said, In the coolness of early spring it's more healthy to go naked. Not for everyone, I reminded him. Unseen influences have infinite ways of developing temperament, desire, suggestion, and motive. The hidden and the apparent worlds weave together a fabric more complex than sky and earth or root and branch, more subtle than sunlight and season.

1:408

OWN YOUR FAULTS OPENLY

This revelation: Do not scold anyone for a mistake you might have made. Do not discipline children until *you* have grown up. Do not taunt or find fault or call people names. Turn those judgments inward. Own your faults openly.

The problem with the study of rational philosophy is that it takes one away from the Qur'an. A reasoning mind cannot approach revelation. Prophecy dazzles to blindness the Aristotelian method.

TO MAKE ABSTINENCE IMPOSSIBLE

You that wrap yourself in a cloak, rise and deliver the message (74:1). These lines brought us the miracles of prophecy. Muhammad had wanted to live in seclusion, but this roused him out of hiding. Be patient in this purpose (74:7). It happened as it had to.

The veil between worlds is the human incapacity to see. A single finger over each eye can keep you from taking in the world. What's depriving you of vision, of knowing spirit, is just that small and easy to remove.

Do you want recognition, good food, music, wine, the ease of talking in a tavern? All that is there in the other world, and more. Do you like sport? The playing fields are perfect. The pleasures of desire? The other reality was *made* for lovers. These gifts have been given by God to human beings to increase the power of their senses, to make abstinence impossible, so we will know and taste what desire is and learn then how to love.

Say *Allah is the only One* (112:1). This means that the different varieties of astrologers and healers, and all the arguing sects of Islam, will eventually go back to the One and be merged together as one.

LUST ALONE DOES NOT CREATE

Men are deeply attracted to women, to stacks of gold and silver coins, to horses and the beauty of plowed fields. These are

the worldly pleasures of wanting and having. God's grace brings in through them another beauty. The lesson is that we should look to the outcome and not be so occupied with the attraction. You have noticed how a beautiful child can sometimes derive from a diseased, repulsive woman? Lust alone did not create the child's handsomeness. God comes in through our pleasures and through our suffering.

Without the divine enhancement that arrives in the urgency of human desiring, people might look like mud-colored camels lying on bare ground. Basically people *are* donkeys concerned only with the straw and barley they're eating, until the presence of grace makes them otherwise (32:5). With faith a grandeur embellishes humanity, as when with a little work by you, God enters a dry seed and makes a fresh living plant. Every action becomes part of this gift. Look around at the sky and the earth. Don't be inert like a wooden bench. Watch the sky moving, and see how every motion in creation connects with the creator. Stars, these natural impulses, our very selves.

Shams Amir Dad and other Persian students of mine often see Muhammad in their dreams. I do not. They have listened to me so attentively and with such open hearts that God rewards them with these dreams.

Grief is better than happiness, because in grief a person draws close to God. Your wings open. A tent is set up in the desert where God can visit you. Wealth that arrives in grief is what we spend in joy. The soul is greater than anything you ever lost.

DOING LAUNDRY

Sleeping people know nothing of what's going on in the world outside. They live in their dreams, and likewise, when someone dies, he or she will not be part of this, but may see into other realities. Seeds and flowers have their ways. Water, wind, dust particles, stars, sun, moon, theirs.

[God says] we make thorns that are very suitable for burning and roses that are right for releasing their essence which can be mixed with juices for healing purposes. That thorns are piercing, that rose petals weaken and fall, both qualities are perfect. Some human lineages feel hard like thorn, some soft as a petal. We have judgments and designations for everything. Seeds look similar, but some grow apples, others pomegranates, quince, pear, plum. But you must take some action to help them reveal who they are. Plant them in the ground.

Cruel people are needed sometimes, kind friends at others. Sword and anger, courtesy and the mirror of docility, use them like different tools. Bodies are coverings that help signify the soul. Let us do our laundry on the river stones, pounding cloth, then rinsing and wringing to hang the pieces of clothing on tree limbs to dry. Now we sit and mend these new coverings as we clean and renew our bodies as clothing for the soul.

Some accumulate honors and social position. We gather the wealth of love and the mystery of presence. Work that does not delight and house the soul is a waste of your days.

THE SIX TIERS ABOVE

There are six levels above this manifest world, homes for the spirit-world beings, angels, a pavilion for the prophets. What is spoken of there is mostly news from the other sections, not what happens here. This earth with its water, wind, fire, and starry orbits is only the first of seven. The six tiers above and the hell underneath are wholly other. The cow and the fish at the top are symbols astrologers use for their fake predictions. Remember that we have been clearly told not to look into that which we know nothing of, for every act of perception will be examined. (17:36)

DOCTRINAL ARGUING

You confuse and waste your time with questions of fatalism and predestination, schismatic nuances, fire-worshiping free-thinkers, idolatry, and all the rest. Yet you rarely examine yourself. What do you truly believe? Try to be clear enough to say *that*. Forget the others and their strange viewpoints. The real path is how the prophets live. That royal road moves east to west and remains true. Others pretend to be on it, whole nations and other groups, but they come nowhere near. They are enjoying their destructive doctrinal distractions. Moses' staff would smash their heads if they were actually trying to follow him.

HOW WILL HE HEAR

As I was praising Muhammad, the question came, *Muhammad is not omniscient or omnipresent. How will he hear what my heart is saying?*

The answer: *Everything connects inside mystery. What you say in this praising gets heard and understood by Muhammad, by the other prophets, the ancient philosophers, and by your living friends.*

No wisdom comes to anyone except through the presence. Medicine, astronomy, works of art, we would be illiterate in these areas if it weren't for that source and shelter. Reading the Qur'an helps us remember that.

BOOK TWO

SAMA

Deep listening has a pulse. It must throb, or it is not alive. The words and music and movement of *sama* flow and follow naturally as a conversation among friends.

As a scoop pours seed, song pours in the bucket of hearing. There may be a few rotten seeds. Don't blame the scoop.

Glasswork takes many shapes. The inward Baghdad curve with its translucent yellow, the Samarcand crimson, the spherical crystal flasks of Bokhara. So it is with containers of music and poetry: *sama* should have an elegant variety.

When we set extra tables and open the doors to invite guests in, we don't serve them something that's gone bad. When that happens, as it will, it's an accident. But if someone is known to *intentionally* serve tainted food, the curse of having done so will never leave, no matter how many generous actions accumulate. Let *sama* be fresh and lovingly prepared.

Poetry spoken with music and movement should roll out like spring thunder with emphasis, emphasis, a softer stress, a space of silence, more thunder, then the dying out. It never goes on too long.

If laughter isn't underneath and inside *sama,* if there's no bright, self-humbling wit, the praise-words will have no truth; the exaltation no majesty. Without humor, *sama* becomes leaden and stern.

Each body part has a musical preference. Each enjoys *sama* in a unique way. Ears absorb sound differently than does the heart. Words spoken with plucked string may jar the eardrum but delight the heart-center, or the opposite: something mellifluous may disgust your soul's intelligence. Kidneys hate it when the fingers tap rhythm. The drumming

makes them nervous. However, the lungs love everything fingers do.

With *sama* let these nine metaphors guide you: a heartbeat rhythm, a lively conversation among friends, the smooth pouring of seed from a scoop, the elegant variety of glasswork. The feel of a banquet, spring thunder, and laughter in the outdoor air. The last includes all: *sama* should move with its multiple harmonic systems working like the organs in a human body, each having its separate function and delight, while carrying along together the *whole* human presence, composed of body, heart, soul, and luminous intelligence.

<div align="right">2:13–14</div>

THE TWO TREES

As I was saying aloud the exaltation of God, I heard a donkey bray. This is disturbing, these impure interruptions. Surely praise for beauty cannot be so mixed? The heart assumes that what it loves is pure. Even when the longing is for wealth, it assumes it is *impeccable* wealth. When we long to hear eloquence, we go to Sheikh Taj's assembly and listen to the talking there, such as it is. Birds lift in the air expecting to be safe. I keep my friends under my wings, so they won't think they are not mine. I include them in my beauty. There is no greater pleasure than being one of *this* species.

Depression comes from being defeated, worn out in the teeth and the joints. You can repair your clay house with clay, but it will eventually crumble away. The elements are always at war, and they always end in ruin.

The world is a tree growing from a jewelseed planted in raw nothingness. Its roots are water and wind, its trunk the earth. Its branches the sky, its leaf-tips the stars, none of which resemble the original seed. Oak trees do not look like acorns. Each tree, every growing thing, has two roots, one in the visible, another in the unseen. Many acknowledge only this visible. They do not understand that the juice, the taste, the thickness of the trunk, and other qualities come not from this palpable place but from the mystery, out of the hidden root. Now, there is another tree. It has roots here and branches and fruit in the unseen. That is the tree we call surrender, submission, *islam*.

2:16–17

THE KHOTAN CEREMONY

I have heard of an old ceremony in Khotan, a region of China where Turkic tribes settled. Men and young unmarried women—their heads uncovered and wearing disreputable clothing—would walk through the marketplace hand in hand. This is how the ritual started, with everyone drunk and dancing, passing cups of wine around. The party would straggle and stagger in before the Khan under the great mosque dome, where the women would partly disrobe, showing their breasts to the men. Lovemaking began there in the open. They did things in public that we do only in private inside our homes. It was part of the annual clitorectomy initiation for the women of those tribes.

It makes me faint to imagine what came next, with the young women passed out drunk. Is God part of everything

human beings do, even this? Qur'an 11:6 says, *Every creature.* . . . This world we watch is strange and disturbing. Here, for instance, are *my* desires at the moment: I want a beautiful woman. I want wine, music, and laughter. I want everyone to see the sacredness of life. I want wide recognition for myself. I want my wantings intensified, and I want to feel the divine being pouring through me every moment.

Answers come for this declaration. *Watch bees sipping juice from flowers. Do that with the mystery of presence. Let your body become honey made from that sipping. We are the unlimited wine you dream of, the reviving light. As you restore that in yourself, you will find fulfillment for every pleasure you pursue.*

Drink *zikr*. The blessed cave-sleep of that will give you peace (18:9).

2:18–19

SLEEPING IN THE MOSQUE

I saw a ray of light in the silent convent . . . hhsh.[29] That same night a woman saw in dream the convent pool filling with water. A servant took a lamp to the water, filled it, then lit the water in the lamp.

Imagine a beautiful young woman who is very much in love with you—a kind nurse, say. You take her hand and walk into a garden or out in the desert, abandoning everything for her in that moment. Now consider how the creator

[29]There is a corrupted word here in the manuscript.

88

and origin of this universe is your beloved. Who could be more faithful (9:111)? How would it be to take *that hand* and walk through any desolation? In that companionship every place becomes visionary and clear like the secret high mountain retreats.

Ecstatic people are not critical of others. Someone far advanced along the mystical path will not start again at the beginning. A gnostic master is wasted on neophytes. The people of the book did not believe until a clear sign came (98:1).

Oman Faqai, a citizen here, and the Sufis have taken to sleeping in the mosque, and because of that they have caught colds. They are coughing. Their sinuses are dry and they look pale and strange. It was a bad decision of theirs to sleep apart from their homes. Roving place to place causes confusion and illness. It is better to rest at night like an Asian boat with your body and mind continuously wet with sleep. Wrong decisions pull your boats out of the water and cause them to dry out and lose their usefulness. Those men turned to lesser desires.

The words *learned* and *Sufi* refer to something very good. I saw Zain Salehin and Muhammad Sufi, and I told them, People say that if I were to die now those terms would lose their meanings. But it is not so. What those words point to does not die, but rather grows more alive after death. Cotton will still become cloth. Dirt and rust will continue to loosen with scouring and be cleaned. The science of our basic knowing survives any disappearance or ignorance, any indignation.

FEELING RAINED ON WITH BLESSINGS

When I was sick, my body chilled and feverish in intimate conversation with the one who brings well-being, I felt dazzled like a virgin girl in her first sexual trembling,[30] breathing like a bride. No one will hear our whispering (21:102).

In the ocean of elements—wind, water, fire, and earth—we have planted a garden for you to walk. We will tend this world as you search for what you love. We will keep the vigor of desire strong in you. As summer heat ripens fruit, we expand your heart to perfection and burn clean whatever needs emptying. This generosity and compassion come into me like the glow I saw in the convent [see previous entry]. I feel rained on with blessings like a handsome king with his new brides, one biting his shoulder, one kissing his neck, another pressing close as though her body were becoming his, or like a young father playing with his children crawling and rolling over him like pigeons and sparrows and squirrels chirping and jumping around the one feeding them seed.

[30]Furuzanfar, the editor of the Farsi text, says, "One word was deleted because of indecency." Not knowing what the missing word is here, but also not considering the passage indecent, we have tried to restore it.

THE BEANS OF CONVERSATION

When I am sick with a fever, I tell my friends that even then I take pleasure in being conscious. It doesn't matter if I'm nauseated or shivering with a chill. I still enjoy being here. Traveling or staying home, both delight. Being alone, being in public disgrace, I am clear and friendly in every state. Only in deep, self-condemning humiliation am I sometimes restrained with my conversation.

Visitors come here when I'm ill or morose, and they don't mention anything about disease or melancholy. They should be more generous. You can say anything here. Don't mind my mood. Conversation breaks up the ground and allows vegetables to grow. Eggplant, radish, lettuce, peas, cabbage. Let talking find its way with no restrictions. Let the long pods sprout on their spontaneous stalks, so we can be fed the beans of conversation.

THE PIVOT

The pivot of delight and praise is friendship. Consider how when you are working in a garden or in an orchard, or singing a song, or just sitting beside swift-running water, how each of these improves immensely if you are with a friend. In companionship pain begins to heal, and joy intensifies.

Two enemies or two strangers will not recognize each other when they move into spirit. From this point on in your life resolve to find more friends. God is pleased when you are together with friends sharing something, anything.

One person meets someone and sees a lover. Another meets the same and turns away. These differences in attraction do not come from your bodies or from your culture. They live innate within creation as secret inclinations. One person loves horses much more than pigs, but pigs have their admirers too. Pigs have lovers.

2:24

TWO WAYS OF WORKING

When I was sick, it came to me that there are two approaches to work. One is bold and quick, fearless in action. The other is worried and constricted with concern about things that could possibly go wrong. If action flows from anxiety, the outcome is murky and disturbed. But if action moves with a swift joy and courage, the world begins to resolve its difficulties and grow whole.

2:26–27

PLEASURE WE CAN NEVER HAVE ENOUGH OF

I tell people I am sick, not to talk about my illness, but to see who is concerned. I look for opening hearts and rarely find one. My own heart was thrown to the winds long ago. People give offerings to statues that cannot eat or see. If I stopped eating and looking about, would I still be less valued than an idol?

I have considered all conversations and every action as the blowing of that wind I threw my heart into. I continuously ask those around me, Do you hear it? You seem to be listening like the blind man who puts his head out the window, but do you understand what you're hearing?

I ask students what kind of work they are looking for, temporary or permanent. Where do you look for answers? They mention the Qur'an. I tell them to ask to be shown what is permanent and what is temporary. The peace of God, the light in the face. There are pleasures that one becomes bored with, and there are others we can never have enough of. It was such a pleasure that came over Moses when he fell into pure being on Mt. Sinai. The Lord turned the mountain to dust beneath him, and Moses slumped in the swoon of another knowledge (7:143).

<div style="text-align: right">2:29</div>

A TURNING BALL OF SILK

This is what I said to Najm Chachi, that distinguished citizen of Tashkent: You stay busy with daily matters so you won't have time to consider the larger ones. Why am I here? What do I most deeply love? How shall I use the time left?

These questions and the answers they bring might make you sad, or they might turn your life upside down. Your speedy mind wants action, not meditation. You think if you don't *do* something, your work will not proceed as it should. As for helping others, your judgment is that one deserves attention, while another would do better if his troubles continued. Your mind urges its agenda, while your heart is saying, *Take both sides, and be in the middle too.*

Here is what your life looks like, Najm Chachi. You require that everyone's attention be focused on you and your work. So there you are, sitting at the top, with strands of silk reaching up from the silk wheels below. Ribbons flow from all directions onto *your* turning ball of silk. As though it were some grand achievement, you arrange the colored bands as they wrap each other on the expanding sphere.

2:30–31

INSIDE YOUR WORK

This was the discourse today: Jobs have certain specific requirements that you do not observe, yet you expect full pay, and when you don't receive that, you get offended and move to another line of work. One spadeful there, and you're off to the next. Keep this up, and in the end you'll have wide experience, but you'll be unemployed and unemployable. Every kind of work holds a mystery that must be lived through. Get up every morning and go *into,* and deeper into, your work.

2:31–32

MINT

It is commonly said that mint and *halunak*[31] belong to the same family, but mint grows from cuttings; *halunak* from

[31]We have been unable to discover what plant this word refers to.

seed. Mint flowers have no seeds. To grow mint, put a cutting in moist ground. After five or six days water it. Thereafter water every fifteen days, making sure not to wet the leaves. Every two years transplant each to freshly prepared soil. Normally mint dies away near the end of June and begins to grow again in late March or April.

Don't plant mint among the leek, garlic, and onion rows. All vegetation draws sustenance from the ground nearby. If they are planted near mint, these vegetables will diminish in vigor and taste. Their health is more important than the mint. In extreme weather, either too hot or too cold, leek and garlic and onion plants are more likely to last through it if they are flooded. Cover them with standing water during these periods, if possible. They will not continue growing the whole year, of course. Endive dies out with the summer heat. Eggplant does best if planted sometime from the beginning of spring until June, the earlier the better.

DROPS OF MUDDY WATER ON MY EYELASHES

Having anxieties and feeling sad about being alive is like piling black mud and garbage on your head. The mud slides over your eyes and the rubbish infects them. You can't see and you get sick. Everyone does this at some time. Try to stop doing it. Let your eyes get clear enough to see the beauty around you.

O giver of worriedness and grief, remove me from my being. Give me the peace of not-being. This prayer, if you can

pray it, will wash the mud off your head. There is a beloved who pours muddy water over the head of the lover, and there is a lover who says, I cannot see you with my eyes, but the drops of muddy water on my eyelashes are filled with the rose of your face.

GRACE AND THE CURVE OF A HIP

I heard someone talking about the beauty of saints and those who live in seclusion, tending the inner life. I said, This love of yours for those beings enriches the soil of your soul. It is a fertilizer that improves the vitality of what grows there.

Likewise, as we look at women, the curve of a hip and beautiful legs are sure signs of grace. As you grow more absorbed with that, you start to see the nymphs of paradise. Drink the wine of women until eventually you pass out. That's a good time to begin your prayers.

In the late afternoon human beings feel lost, and they are, except for those who are discussing with each other the nature of truth and good action (103:1–3).

GRAFTING THE RED ROSE
TO THE WHITE POPLAR

Some plants have roots that may or may not require attention. The vines, the white poplar, and the willows have grown well

in previous years, and this year if they are transplanted before the leaves and blossoms come, they will take root. They must be put in the ground in the spring, though, not in any other season. Other trees too should be planted before they get their leaves and blossoms; however, some of them will root if the blossoms are out just a little but not fully.

If you are planting seeds, plant during the first summer month so they'll get plenty of water. In winter when they are covered with snow, seeds begin to break apart and get ready to grow.

Red roses can be grafted to the white poplar tree. Cut a slice from a poplar branch about the length of a finger. Cut and peel a branch of rosebush the same length. Place it along the cut in the poplar and cover it with the skin of the poplar. Cover the whole section with clay and bind it with linen cloth, then cover the whole thing with wet mud. The poplar will absorb the moisture into the grafted place, and roses will begin to grow from the poplar tree.

Moisture rises through tree branches in spring. In summer the water recedes back into the roots, and the top branches become dry. In their limber spring wetness trees can couple with other trees. Apple can mate with quince and quince with apple. To make this happen, shave a freshly cut apple branch to a sharp point like a writing quill. Then cut the trunk of a quince with a knife. Hold the cut place open with the blade and push the sharpened apple stick into the opening. Remove the knife and put mud in the area. Cover it with some kind of material and bind it tightly with a cord. Cover the whole area with mud. The two will grow together, if you do this in early spring before the blossoms are out.

In the villages they cut thin mulberry branches, rub them with long wisps of fiber, and put them in the ground in

spring. After a year bunches of mulberry plants come up and leaf out. They pick the leaves and give them to their silkworms to make cocoons. The next year more mulberry plants sprout, and the same thing is done.

This world is decorated with such pleasure, such noticings of natural process. Fruits, trees, creekwater, fire, smoke. They tell us how they are passing through and away and how there is a perception of spirit beyond this science of what is visible and growing.

<div align="right">2:44</div>

A PRELIMINARY MOURNER

As I sit comfortably somewhere, my stomach begins to hurt. Then there's the unmistakable twinge of tooth trouble. Dark blotches appear on my face. I have constant diarrhea, and sharp knee pains afflict me when I walk. So age descends upon this form.

These complaints will increase until I go through the death gate, and if I continue like this to moan my maladies, I'll have no time for anything else. I refuse to be a preliminary mourner in the procession toward my own demise. From now on I'll give this rapid disintegration no notice.

I'll pretend to have hit rock bottom, alone, abandoned to die in some wilderness of disgrace. However, even here I take delight in being alive, and I still have a few desires I can follow. This old corpus lives. And then it dies.

HONESTY

One who tells the truth is wealthy now and blessed in the world to come. As for the other kinds of income, your friendships help with those. Let the inner richness of honesty be enough for your soul.

With non-Islamic people, continue to act under the Islamic code. Tithe for the poor, and forage in others' crops only to provide your family with that day's sustenance.

LOSING GRACE

Muhammad gave blessings on the people of God, which reminds us that we *can* lose grace. If the ability to provide for wife and children were certain, there would be no worrying, but there is. There are light-blocking greeds and meanspirited lusts that hang like smoke on our paths and make us stumble. If one morning your springwater vanishes back into the ground and the creekbed dries up, who will restore the bright flowing (67:30)?

PAIRS

Real work gets done in pairs (51:49). Find your companion. You will know him or her when you feel completely humble in that person's presence, and when you trust that person to lead you along.

Appearances get tricky at night. What you perceive as your child may turn out in daylight to be a dead donkey's severed head. You see a dustcloud coming toward you across the plain. You think it's a famous horseman and feel so honored by his approach that you put on a fresh, more elegant robe. There is no horseman or horse, only horseplay.

A duck skims down in a mudhole and dips its beak around vigorously looking for worms. The wings get heavy with mudsplatters. A passerby stops and scolds the duck for being greedy. What the hell business is it of his.

FANATICISMS

In answer to the Rejectionists and the Heretics, I say that I would also be the enemy of Abu Bakr if he were as you describe, and the Khareji sect as well, if they killed Ali. I oppose Yazid and his kind who degrade the family of the prophet, and I would strongly defend Muhammad against those who are cynical and sarcastic about him, be they Christians, Jews, or false relatives. But people who know about such things say that I should not accept your characterization of these matters, that they are based in various fanaticisms.

Hanbaliyans, for example, speak of the "likeness" of God as being composed of blood, disease, air, water, inanimate material, and things that are novel and ephemeral. This is ridiculous and really only about terminology, the words "likeness," or "effigy," or "idol." Such controversy is always over the definition of certain words.

In the midst of doctrinal animosity you may love someone whom others consider the enemy, imagining him as having all sorts of despicable traits. You say, I agree. I would also oppose him if he were like that.[32]

Materialists and free-thinkers, for whom anything is allowed, argue among themselves like children who know nothing beyond what's directly in front of them, or like donkeys who understand only with their stomachs and so comprehend a pile of fodder pretty well, but nothing else.

MY MOTHER'S TEMPER

My mother's mean temper is no doubt something people talk about regarding me, how unhinged with anger she is and how I can do nothing about it.

I could tell her my sense of her behavior and how she might reform, but she would just belittle me and my ideas. I'll stay put. Anyone who wants my advice can come to me. Offering advice when someone doesn't ask for it is like throwing bits of paper with words written on them into a fire.

[32]This italicized section is a marginal note written in the same handwriting as the text.

Dervishes need not explain why they do what they do or don't do what they don't do.

2:67

A BEAUTIFULLY PLANTED PARK

He made the earth submissive to you. Walk in those regions, knowing that (67:15).

You should expect grace, that which makes life more than manageable, but you look elsewhere, wanting some delight other than that.

Your conscious being, with what you've been given, should be like a beautifully laid-out park with wildflowers and cultivated wonders, a swift stream with secluded places to sit and rest beside it.

When a grieving person sees you, he or she should recognize a refuge, refreshment, a generous house where one need not bring bread and cheese. There will be plenty.

2:74–75

FUMES

Clean clothes and expensive accessories will not cover a blackened core. The smoldering sends out smoke through the crevices. You brush the fumes away, but they keep coming.

As his criminal actions have built walls around a prisoner, so your forgetfulness and refusal to let light in keep your soul from traveling.

VARIOUS FEARS

Qur'an 98:8 talks about the *fear* of the Lord, but what *is* that? Fear of something else, anything other than *the Lord,* is not like this profound trembling. Everyone has the initial fears appropriate to the human condition. Then faith grows, and the fear of the Lord comes in as root-strength rising in a slender branch. Take it up and have no fear (20:21). Moses' fear was grounded in his refuge.

This is my prayer: I give my fears to you. When I am sick, bring health. Dying, give me life. Make my deepest degradation a glory. And when I want the beauty of a woman, give me that. Make women more beautiful and my wanting of them stronger.

WHERE'S THE REST

We adore our beautiful children. We wander town shops admiring merchandise. We pull back the curtains. We see things made of gold or fame, of empire and the other attracting powers. They will be veiled from their Lord (83:15).

Remember how the staff of Moses changed and suddenly swallowed Pharaoh's armies as though they never were. We sit here moaning our losses, busy with the dwindling details, which are nothing, already gone, scraps thrown to an alligator, who lifts his head and says, *That was not much. Where's the rest?*

So carefully we prepare the decorations we are going to wear. Let me help with that. Here, this way. Friends, instead,

let's reveal our fake layerings of ego. Tear those away. If we work at this together, we may be able to discover our pretentions, the cruelty and the foolishness, and ways to live without them.

2:87–88

MORE POWER

Motion and stillness, dividing and gathering, these are forces that work the divine will in the manifest world (100:9–10). What goes in the grave is a powder scattered by the wind. What moves in the heart gathers and becomes manifest.

Those in power are of two kinds: the uncertain, tentative man who breathes hot and then cold, like the old man from Chagha and Balkh, and myself when I feel weak. Then there are others who are always looking for more power.

Anyone with power comes under a higher dominion. You wasted what you had. Now you ask God for more. A child plays with his mother's spindle, using it for a top, and breaks it. He asks his mother for another one. Even if she has it, will she give it to him? Of course not, no matter how much he cries.

What would you try to accomplish with the additional power, and what experience have you had in doing such work?

FREE CHOICE AND FATALISM

In Khwarazm the great majority are Mu'tazilis. No one there *ever* claims to have had a *vision* of God. The people think of themselves as freely acting makers of their own lives. If they meet up with a Jabriya, one who believes everything is predestined, they cuff him about the head and say, *It's God's plan that I do this.* Khwarazm is tough on predestinated people. Their houses are plundered, and as they walk about in poverty, they are clubbed and beaten. Mu'tazilis, on the other hand, enjoy the wealth they seize from the Jabriyas, these lazy ones who never initiate anything. *That is God's business,* they say. Theirs, evidently, is to suffer in both worlds.

VITAL COMPANIONS

People approach God according to their levels of understanding, some to discuss profit and loss, others to find a name for the divine mystery. Others are interested in astrology; others argue being and nonbeing.

Assertions in this area feel to me like being lost in a jungle with no familiar landmarks. There was a time when everyone had different names for God. Then the ninety-nine qualities came through the prophets.

I suppose we should ask the advocates of predestination whether they oppose crime or consider it part of our fate as planned out and directed by God.

If all nations were equal, there would be no ambition, no jostling for advantage, and no vitality. The essence of humanity is a nervous, competitive fire. When that goes out, we are motivated only by hunger and thirst and sex like animals.

The doctrinal position of the Mu'tazilis has strengthened in me as the ideas of the predestinationists have weakened. I tell my students that we are like an army resting in camp, used to an easy life with lots of military benefits. Then we look, and a well-organized, well-equipped force is almost upon us. As we run away, we are wishing we were part of that opposing contingent.

We're talking easily with friends; then something happens. Someone new enters the group, a new subject, and the air is full of confrontation and challenge. Some of us stand aside and observe, waiting to see who will win. Others pretend to be content with either side, but then they see that some are living better. They become upset. It's not good to spy into people's houses.

Conflict comes into the heart area because the ego and the soul are living there in the same place. The *nafs* (our animal, desirous energies) and our longing for God (the clearest part of human intelligence) both inhabit the heart, the source of love.

If a man lives in a house dominated by a woman, things will not go well, or end well. A delicate balance is needed for the harmonious life. A woman is a mirror. Do not throw stones at her. But also, as a man, do not become an ethereal vapor that flows magically into the mirror-world and becomes that. God has made women nurturing and attentive and given great value to their diligence.

Soul and personality can live beautifully together as man and wife, married. Don't let the ego take charge of soul-growth. And also, do not dissolve the personality completely into the spirit's intentions. Let both stay strong in themselves as vital companions.

2:95

A BOAT NAMED *QUANDARY*

Whoever calls this place *home,* and means it, stays lost and unsatisfied. This plane of existence is a wild sea surface. We're in a boat named *Quandary,* sometimes pulled partly under, then thrown by the waves up in the air.

But if your heart lives in eternity, you will feel peaceful in what we call *islam,* the calm depth where there is very little tidal fluctuation.

You have a *quiver* for the arrows you hunt with, but when you hunt for God, is there a *quiver* inside you? Is your search alive and *trembling?* If you forget about it when you're happy, or if you postpone it in physical pain, your hunting will be a false pretending like the popular song,

> I love her laughing, drunken
> eyes, her curling hair.

ALIVENESS

I search for what is truly alive, wanting to be clear with discernment there. I read in the Qur'an 17:110, Call on God the most merciful, the most compassionate, or use any of the gracious names.

When you move into those qualities, vitality and intelligence increase. The energy that builds a city, minaret, and archway colonnade comes as a gift from the qualities of God, the same that holds the sky in its motions and the mountains in their stillness (51:47). When you cannot sense this being held, nothing interests; nothing delights or makes you wonder. Human aliveness fades as vision fails to see the source that makes and moves through form, shaping events.

SOMEDAY

Tajzayd, my bright companion here in Balkh, says that everyone is held by some desire, but I seem to have none. I must be free. Lovers do not look back to beginnings or forward to the end. They are simply here, seeing *this*. I have nothing to do with how this place and moment became itself or with where it leads.

Those around Tajzayd say that when we are drawn to someone, we are binding ourselves with the attraction. So we build our confinements, but it occurs to me that one who turns away from a friend will be even more miserable. Those with no desire live in pain-prisons unique to them.

Tajzayd also says, *I am a beloved.* This is easy to check. Lovers always gratify the beloved, so there will be no pale longing in his face, no lines of concern.

Tajzayd, even these Yepaghu Turks here surpass you as a lover. You keep a wedding hidden in your heart, saying, *Someday,* whereas they celebrate openly *now.* Your lover may look different by the time *someday* comes. Do you expect permanent union in a liaison that lasts only a few days?

Can they understand the Qur'an, or are there chains and locks around their hearts (47:24)? Go to the Qur'an. Leave whatever confines your heart. The key is already in your hand. Respond. Turn the key and walk out from how you have closed yourself in a *conception* of love.

2:100–101

A BLUR

You move into prayer without properly washing after you go for your morning toilet. After praying, you ask special favors. *I have sinned. Don't let me be disgraced. Please don't punish me.*

It is God's generosity to forgive, but first you must fear the inner consequences of your own forgetfulness. Only when you feel a deep helplessness and truly hope for a salvation that comes from beyond you, will grace flow into you.

Proceeding through the day in your normal sloppy and selfish way, you will only grow more and more insane. You make idiotic remarks to people, claiming to have accomplished this and that *yesterday.* Out of such confusion you will do nothing of value.

You are like a fig tree that is not completely rooted and not quite uprooted either. Like a vine pulled loose from a

wall, you are not completely visible, nor wholly hidden. A cloudy blur, not yet moving in a clear direction but not still either.

BE EASIER WITH YOUR PLANS

I was wondering what sort of learning I should take up next, and my considerations became tedious and exhausting. I turned to the verse, Say *The enjoyment of this world is short-lived* (4:77), which tells me I should take up whatever comes next without puzzling how it arrived or what the possible consequences might be. Accept the pleasures given, and don't try to keep them with you. That's addiction. The intellect's interests and pleasures are running water flowing from the east and from the west. Taste and let them go. When grief arrives, don't try to think of ways to prevent it happening again. It will. Sorrow masses overhead like cloudcover, rains down pain, breaks up, and moves on. And don't divide your sustenance into strict daily allotments. Be easier with planning your life, less rational. When you were sucking your mother's breast, did you count the holes in her nipples? Milk came as needed.

TENDING CHILDREN

Muddled in motivation, not tending to the children or to my work, whenever I hear a child's voice calling in the street, I wonder about *my* child. If I spend my life worrying about offspring, I might waste a lot of time, but if I ignore them, they might waste theirs.

DECISIONMAKING EXERCISES

I gave my students these problems to contemplate. A man has ten shops offering five or six different kinds of merchandise and services. His expenses exceed his income. Something must change. He considers leaving his town to live elsewhere, but he has lived in that quarter for years. He has friends. He's part of the community. Can he give up such closeness and familiarity?

Consider also the situation of the husband of a woman who composes songs and sings them in public. One day he arrives home unexpectedly and finds her with another man. He storms out, vowing divorce. Later he remembers the prepared meals, the clean clothes, the warm bed, and the excitement of living with a woman who sings beautiful songs that she composes herself.

How are such decisions made? Does each approach the moment of impasse with different necessities?

SOME UNFIXABLE TRUTH

I tell the Persian speakers that all activities have one object. Work, holy warfare, other kinds of warfare, prayer, and every good action lead toward one point, your relationship with God, the growing awareness inside the mystery we live within, and that lives within us, the faith of many names, and none. THAT which can never be *said,* or held in a word.

Our response to this mystery is composed of two emotions, hope and fear/awe. The feelings inside fear are often reckless and violent. Inside hope there is tenderness and love, and the one is always present inside the other. Fear lives inside hope and hope inside cruelty. This manifest world comes into existence with these two innate within it.

When Caliph Omar and the king of Ethiopia heard this, they immediately wept. Why is it we *don't* weep? It may be they heard in this news a tragic depth that we don't hear, some truth that is hard and unfixable.

Those close to the *kaaba* are more courageous in their knowing than those in the outer circling. They keep the original wetness inside their limbs, that which will save them when fire comes, whereas those who have let life-troubles *dry them out* will quickly burn and turn to ash.

DIGESTION

I have eaten a big meal and now ponder the matter of how everyone's stomach is filled with different food and drink. Revelation comes: These vegetables and fruits, these pieces of meat,

the colorful sherbets, the hard and soft-crusted breads, they're all *alive* inside us singing praise.

And just so, people and animals and the spirit-beings that are here are food that is being tasted, chewed, and digested into the mystery. As this process happens, gratitude gets released as energy.

Stars rain down their omens and influences, and so the constellations become the air we breathe, nourishing the plants, the animals, and us, the human beings, who have devised this language by which we exalt, pretend to be, and anger God.

As I remember rose gardens and other comforts, I notice dark blotches on the back of my hand. No surprise there. Trees begin as limber saplings; then they stiffen with a thick covering of bark. The same has happened to my hands.

Out of my praying dark-eyed women arrive to distract me. This is also natural. There are *so many* forms of desire. Then children come, and new ways of loving, new sweethearts. It's hilarious how wantings change even as they produce progeny, with some infinite laughter behind it all.

Remember God in everything you do. For example, looking for a taste of lovemaking, remember that that sharp pleasure and the drawing-together toward it come as gifts from your Lord. Even inside a seizure or a stroke, recall, if you can, that the presence living within earthquakes and tremors is the same that's trembling inside you.

I have observed nothing in this life more powerful than the deliciousness of love. Inside our most profound senses of glory, surrender, and humility there runs the thread of wanting to love and make love. The other qualities grow *out of that*. They spawn inside the God-pulsing delight.

LOVEMAKING

Sex is a fire kindling at two points: in the tree-green sap-wet semen of a man and in the smoldering womb of a woman. If love for the man is not deep inside her there, no lovemaking flame will rise.

SEED AND COUNTRY PEOPLE

I advised the emissary from Khwarazm to wash his hands of that region, to cut all ties with it, because of the attack Ala'uddin Muhammad Khwarazmshah has directed against Khorasan. I did this as a warning, and I use his predicament as a caution for us, that we should make sure before we undertake an action that it will not cause disaster or suffering for anyone.

We should be more like the country people who willingly give up sleep for their work. If crops come up abundantly, they have their reward. If not, they'll have it in another realm. The walls of this material plane have a backing. Inside every greenhouse, a garden. Inside this greenhouse world grows an eternal flower. If eternity weren't real, we would not say this is *transient*.

Set out the likeness of life as water we rain down. The plants of the world absorb it, that in the morning are pieces of straw blown about in the wind (18:45).

What goes in the grave gets scattered and lost (100:9–10). What's in the heart keeps growing and becomes more manifest.

Seeds in the ground are like pure beings in the tomb. Rain comes. We wash these seeds in their graves, and as with the sleek semen-coffins inside a womb, there come out new faces, new trees, hands and feet never seen before on earth or in the oceans, new beings with presences never felt in this surrounding air nor among these stars.

I made a serious decision to bring my work to some conclusion. I am God's gardener, and I want the master to be pleased with what I have done to show his creation in a clearer way. So I made a resolution. Then I grew weak and inarticulate. Difficulties *do* present themselves. But as I tell the people around me, even if your body breaks down and your ability with language diminishes, you will still be fine—no blame will attach—if the foundation of your *intention* stays clear.

WHAT TO BEGIN NEXT

I can't decide what work, what study, to begin next, among the several possible. If there is no spirit, no soul, no divine dimension or value, then whatever we do is just killing time, meaningless and idle. On the other hand, if God and the mystery of spirit overlap with this time and place in simultaneous layering, then *anything* we work on performs eternity and is the very motion of mystery. Each gesture and word and idea appears in this moment's presence and in the *other* as well. This is a great truth of being.

Whether a particular action leads toward a future heaven or hell is not worth considering. Even when you will die is not important. Eternity creates itself at this point. *This* moment is

where you grow nearer and nearer God. Time and the infinite curl together in every nick, touch, taw, tine, and root fiber. Here and now is where you can be shown the miracle of what continuously occurs.

<div align="right">2:131–133</div>

TROOP MOVEMENTS
IN OLD BATTLES

For the past hour I have been confused and unsure of what I really perceive through the senses and where and how a new perception might begin. What if I were God? Then this manifest world would show the distraction I feel, or else my joyful creative mood. Contraction and expansion, both would be total. And since this is my secret place where I can say anything—no one will ever hear—I advise my students to free whoever cries out for relief. Allow the flow and spaciousness of fulfillment. Don't block a strong desire. Let coverings fall away as they will, and must.

The esteemed physician prescribes that for three days before blood is medicinally drawn, you should drink a juice mixture of four parts dark-red jujube fruit and one part plum.

Also he says that as you are being bled, lean back on cushions and relax your mind. Have three glasses of red wine during the process, or if not wine, a mash of sour grapes with sugar added.

I am always glad to see Khwaja Hajjaj; then he starts talking. A noble man from Samarcand, but disturbing to listen to. He told me this incident, for example:

There is a woman who kept some bread for eight months.

We must eat this bread, she tells her husband, before it gets to be a year old.

Take off your clothes, replies the husband. Let's go to bed.

There's nothing wrong with these clothes, and why do you want to go to bed?

If we don't, I'll be sick for eight months.

In a more mystical vein, Hajjaj claimed the following vision:

While I was praying, a man appeared in front of me. His eyes had deep lines beneath them from continuous weeping.

He talked with me for a while, then walked away through the wall, not using the door.

Another boast of Khwaja:

I have traveled three hundred and fifty miles with no food or drink. Every month I live on four and a half kilograms of flour. I make bread and let it dry, then I crumble it and sprinkle water on the crumbs. That is my only sustenance.

Khwaja's stories make me *less* sympathetic with him, and with everybody. Sometimes when I am alone, I recall incidents I have been told, things that happened in the battles at Samani and Khwarazmshah, at Khatabi and Qhur, and it occurs to me that thinking about what has happened to others is

mostly a waste of time. It is more helpful to remember your own life.

Pay less attention to kings and troop movements, the squabbles for power. Let big outer events go by without much notice. What's real is your friendship with mystery, the intuitive communion there.

THE UNIQUE QUALITY OF YOUR DESIRE

A man from Samarcand said, If you kill me, you will be known as a warrior. If I kill you, you'll be a martyr. Then he whipped his horse and rode off before I could set him straight.

Our imagining of spirit is as if we're standing on a mountain looking into a valley covered in dense fog. As we go down inside it, the fog becomes green and full of detail, trees, running water. This is how passing through death into spirit will be.

There are many kinds of mystics, many flowers of knowing. Which genus are you? Your children may well be very different species. There are those with total trust like Ishmael, and those like Abraham who stand up with a knife drawn, ready to sacrifice Isaac. Then there's Aghun-Sha, who discovers his son buggering, or being buggered, in front of a grocery shop.

Pay no attention to gossip. Don't worry about your sons being like you or different. Each soul is unique in its longing. Rely on what you yourself see and experience. No one can know the way of your preferences, in food or drink or sex. Your father and mother and your children do not feel the qualities of *your* desire. That is yours alone to know.

So don't let others interfere, and you should be careful not to interfere with anyone in these areas. That can become a disaster for everybody.

2:138–139

STUCK IN A NOWHERE TOWN

I was mumbling my frustration at being stuck in a dingy nowhere town like Wahksh, while others enjoy Samarcand and Baghdad and Balkh, the lovely accomplishments of civilization. I want more grandeur and depth around me.

In answer: If I am your companion, you need not be *anywhere*. If you do not live inside this Friendship, wherever you are will be dangerous and disgusting. You will feel terribly alone. Compared to this companionship, your hanging out with Sheikh Taaj, the policeman Mo'in, and others who work in the government, those associations have nothing *essential* about them. You are on the path of truthfulness and heart. Whoever you meet there will recognize your integrity, your true being.

Sometimes I suffer from a thought that events occur at random, and that there is no point in trying to alter their course. These ideas lead me onto painful tangents, one of them being that God moves through cruelty as well as kindness. Another is that God has no part in any of this.

We must live from the center. These flurries of confusion come when we have nothing we are led to do from that core. As you finish one heartwork, go to another with no break, and with one objective: to enjoy the taste, the dignity, of lightedness and Lord.

NAKEDNESS

I am afraid for anyone to see my faults, my baldness, my privates, the body flaws I hide with clothes. But bride and bridegroom see everything about one another. They can be many ways with each other, tender and mocking, playfully rough, any way at all, because they have no fear with each other.

Likewise, the mystery of God knows everything about me. Here, out in the open in front of that, I say, Do whatever you want with this body. Every part of me stands naked in front of you, like a new bride ready for whatever will happen—love, fear, service, difficulties, humiliation, delight.

BUKHARA FOR CONFECTIONS

How would it be if we were to have the same soul-centered feelings at home as we have in the mosque?

I tell my students that what they *do* will not alter their basic nature, though it may change acquired characteristics.

What would happen if all the shops and trappings of this town were suddenly replaced with those of another? Then after a time, if that wealth and means of getting wealth were transferred to another city, perhaps the one where you grew up?

Sometimes when you move trees, they don't grow where you transplant them, and your work comes to nothing, but you keep trying. We have ordained diverse ways for getting sustenance (41:10). Each place has unique advantages. Certain

soil is right for date plantations, other land for peach trees. Bukhara has become perfect for making candy. These beautiful variations keep the world orderly and prevent overcrowding.

When I feel myself back in that creation-time when the different organs of my body were being sorted out, the minerals distributed, the mountains blooming in their places, the lifeforms coming to life, I feel the presence of spirits bringing flowers, beautiful women with music, and trumpets welcoming the human consciousness. Then I return to a more constricted state, apart from creating, a dull confinement. From there I can see only a crowd of mean, destructive people blocking the road.

<div align="right">2:143</div>

THE GREAT CROCODILE

I tell those around me that if you turn away from the core, your soul—the seat of glory, as it has been called—you will fall into an unliving stupor (50:19). The great crocodile comes and crushes your ship. Eyes go one way, ears another; your intelligence skews beyond reason. This disaster can visit anyone.

When your ability to choose comes back, your identity will strengthen; ear and eye will realign, and you can again be a friend, a lover, a devotee.

CURE FOR A BAD STOMACHACHE

The son of magistrate S'ad had a bad stomachache. He treated it by eating violet-root with sugar. Then for a few days he drank sugar water and lay on his stomach for a certain period each day to let the liquid collect in the place of the hurt. A few days of that and the contractions stopped. His belly relaxed, and there was no pain.

MY MOTHER'S SADNESS

A musician sweeps the strings; my mother weeps. I lie down inside her sadness hoping God will let me sleep, but that release does not come. My insomnia and her sense of being apart from grace pile their pain on my disheveled heap.

TUFTS

My intellect, perceptions, and memory are tufts of flowers in the hand of mystery. You give them value, direction, and shape, as you gave the Torah to Moses, the Qur'an to Muhammad, the Sermon on the Mount to Jesus, and the Psalms to David.

A LITTLE CRUSHED BIRDLIME

Nuruldin ate various things before sleeping. He felt some pressure in his chest and fevers and chills for which he drank a barley mixture, a lot of water, a little crushed birdlime, a piece of jujube fruit, lily root, and orrisroot.

He feels the orrisroot particularly helped. Usually a barley decoction is not good for stomachache. It causes constipation.

ANY MORE THAN A DUCK

Release and let flow *through* you anything you feel has become *yours*. It may be a thought, a stance, or something more material, a house, a table, a horse. Isn't it clear that existence comes from nonexistence? We so deeply *know* that without understanding it. Delivery arrives from the invisible. In that moment there is no room for why or how.

What we *can* do, though, is *see*. We admire the growing garden, the fading sky; we taste the blossoming conversation. All songs and motions have purposes we cannot say, any more than a duck, with its joyful body floating in the love of a river, can explain its happiness.

Be absorbed in being, in this sweet weather, pleasures coming and remembered. Fully here, you *may* get to look over into the other and feel its wholeness filling you.

BAGHDAD AND YOUR BODY

A baby comes from the mother not knowing this world or the other. He or she grows and begins to understand a little of what is taking place. You speak of the invisible world, but no recognition comes to the child. This is the sheer dropoff of conception.

Prophets have a different vision (32:23). Muhammad moves from visible to invisible and back again to the visible. He sees his personal form and at the same time the essence of all being, skeleton and soul. This may seem like a divided condition. It is, and it is not.

Walk on top of the veils that partition off our ways of seeing. Moving *through* them is the longer way. From above you see God and the universe as one. If even a second of union has ever happened in a human being, how can *distance* be the truth? Someone tells you, *You must go to Baghdad*. But Baghdad and your body are already together. You live in that city.

RIGID AND ETHEREAL

Looking at hardpacked clay, the clods in it like rocks, I am amazed at the miraculous variety God grows out of it; not just greenery, but our lives, these intelligent friendships and love, awareness and soul, the method of water inside the ground— there are so many delicate extrusions and enthusiasms pouring through the harsh matrix of this high desert plain. Think

of the thick metallic petals that close around the soft cotton fiber.

The mystery arranges what is rigid and what is ethereal so that they work together. If there is a shortage of density, it transforms porous to bricklike, the model being the way climatic moisture loosens a tightshut seed, then how the plant that grows from that seed draws up and holds *encased* the ambient rain.

ONE NIGHTWATCH

When I had children to tend to, I was often brokenhearted and upset.

The Turkish Khwarazmshah captured many areas with households, children, nobility, merchants, and even prophets. But there seems to be no purpose to his seizure of power. Success mixed with indecision, procrastination, and missed opportunities brings disaster.

A devil might overhear angels making plans, but his purposes are so different that the knowing beforehand gives him no advantage.

An astronomer whose knowledge comes from one fourhour nightwatch of looking up at the stars now proposes a theory for the entire universe.

HOW ALIVE DO YOU WANT TO BE

Would a frying pan ask the sun, Why are you so bright with me so dark? That is simply the appointed way (6:96). I was praying, telling God how this life is true and reliable.

Wherever you are certain in your knowing takes on a fire, a life, as various parts of the body thrive with praise. How alive do you want to be?

Spirit and discernment gather; the cogency builds. The desert mountain in Sinai becomes a glowing membrane when Moses is walking there. Solomon's awareness lifts and lights with the birds wherever they go. There are beings who live because other beings have light, and there are beings who die because someone let his lamp go out.

MIRACLE NOTES

Sharaf Sagzi says that when old people meet and sit together, they often talk without speaking. They inwardly understand each other. For example, they intuitively *know* that women do not desire sex with other women, and other matters like that.

There are many miracles recorded about sight being restored to the blind and new vitality returning to what has lost it. When Joseph unveiled himself, the light of his face, the *nur,* entered a blind man's eye, and the man could see. A blind man came to Muhammad once and prayed to be healed, and he was.

Joseph prayed, and Zuleikha became young again and bright-eyed. A man said to Muhammad that he fell in love years ago, but that now he and his beloved were old and indifferent. The prophet prayed, and the lovers grew young and passionate again.

An invading tribe of herders pushed Lot's cattle onto rocky terrain where there was nothing for them to eat. Lot prayed and the stones grew soft and moist and fertile. Lush grass appeared for the animals. Lot threw rocks at the intruders, and they were blinded.

2:164

TWO DREAMS

A Turk's recent dream: A thousand men in white are standing behind Bahauddin as he leads the Friday prayers. They want to spread around him in a circle, but others are urging them to stay as they are, saying that by attending prayers in this way they will receive justice and mercy on Judgment Day.

He also dreamed that I was in a building with a great crowd. I did not know the extent of the structure we were in. I held a long rope that stretched back into endless distance coming to here where I held the end, which I was braiding, and moving forward as I did.

OWNING IS INHUMAN

When you have nothing to do or feel blocked by circumstances, when you feel like you have no life, go to the one who moves within motion and inside all work (55:29). The accomplisher *and the deed* of the universe. A hundred thousand miracles, a hundred thousand cities.

Look at these doors and walls, the air; every crafted object once had vitality, awareness, and spirit. One day each will have those living qualities again. See these things as good friends, lovers, as a town, a community you have lived in all your life and feel blessed to have around you.

Owning part of the world is inhuman, while *not* reaching for a piece of it is the essence of being human. One scenario is a dogfight. Another, a virtual struggle where one spends his wealth to have friends nearby. A more peaceful way is the love men and women share in a family, the concern they have for each other and their children. Their worries about health and death, about their own unworthiness, and whether they are spoiling the children. This humility is sanity. When you see no good results coming from your work, be steadfast and ignorant like the donkey who carries a load on his back with no sense of what it might be worth. He just keeps plodding, looking forward to his feeding time.

No one knows what warm winds bring, or cold, who they may help or afflict. There is nothing in the world and nothing in experience that cannot turn beneficial, or damaging, in a moment. Even each of the ninety-nine names, the qualities of God, have grace as well as anger inside them. The monstrous is pushed away with a rough hand, the lovely drawn close with a tender.

CONNECTING SENTIENCE

If creatures have no connecting sentience with God, how can they yield to, rest within, and enjoy the presence as they do?

Revelation comes: Creation derives from this, so everything is inside this peaceful friendship.

Animals, humans, birds, insects, everything lives within God's qualities. There is a tameness settled in the wild. Any motion of drawing-together in lust or love, for companionship or conversation, telling secrets over a table, walking the street laughing together, all of it takes place inside the mystery of 2:255, which says, There is one living being, only one.

ORBITS OF ATTENTION

A servant of mystery sees the beauty and the grace, and against that his own helplessness and cowardice. He knows how ugly and distorted he can become. What we give attention to we grow to be part of. When you notice a dog, you enter the dog's life. You have made me see your cat, so I will *be* your cat. If you look at a wound with pus coming out and blood beginning to clot, say, I am this blood. At a garden, I am these flowers. At a woman, I am God's lover. At the incomparable vastness, that; at the most pitiful, heartbreaking stupidity, this. Prophetic radiance, of course.

Orbits of attention conduct you through many identities. Don't be surprised at anything you might become.

CHANGING SCHOOLS

Fakhruddin, son of Sheikh Taaj, says that Jalaluddin went to one eminent Sufi lodge, then left to attend the learning community on Motawakkel Street, where they ask him about his changing schools.

Too much repeating of formulae, *alhamdulillah* and *bismillah,* all praise to God, in the name of God.

Well, you should come to my place, says Fakhr Qallasi. I have a community where we never praise anything. We never mention God. You'd like it. There is no prayer, no ritual cleaning, no kneeling, nothing. It's very quiet.

PLANETS AND PLANTS

By the stars that leave and come back (86:11), by the ground that opens to let plants grow (86:12), planets are both star and plant. They open to let starlight reach into us here, and plants are like planetary bodies, moving through the seasons, and nobody knows where they go when they die.

Someone wakes at dawn confused. Why should the sky be the cause and earth the affected? Why not the other way?

Every star is a leaf-tip on the sky-tree, whose leaves are the size of a country, with the nightsky turning under the sun's leaf. It will not be surprising in the spirit if a great assembly gathers under a leaf, leaves there being many times the size of this universe.

SPRING 1210

Judge Fazari dreams of Bahauddin high in the air, explaining to a crowd the phrase, the Lord on the throne of glory (85:15).

Two men of Turkish descent report that a sick young man has had a waking vision of Elijah and Khidr. They came to him through an opening in the wall with this message: *Go to Bahauddin and tell him the king of Wahksh will rule another ten years. Then the monarchy will go to Qelej Takon, not Yegan Takon.*

These came during the spring of 1210.

COMMENTARY

The most alive, the self-being. There are no likenesses or words for (IT) (THAT) (WHAT). We throw our cameras into the void and look confused. A feeling, an in-knowing.

With not much relief in finding synonyms. Talk in this area stays inane, or edges toward music. How does one *feel* about three hundred billion galaxies, or a dolphin, the white oak in the yard? Grandchildren.

The language-shuffling mind remains frustrated, to its credit, humble and ignorant, in the embrace of living fullness, the gnostic PLEROMA, a godzillion tarot cards in a class-five tornado. That mystery as it is realized, in some coherent way, comes to be called faith, or simple waking. An oceanic being-held, a myriad-winged sacral hearing, the fluid fire that walks about as everyone's inwardness.

Many have spoken of four modes of consciousness. This awake state, dreaming, dreamless sleep, and a fourth way with no name that in its pure beingness includes the others in itself. As I have worked on the poetry of Bahauddin's son Rumi these past twenty-eight years (rephrasing the English of scholarly translations from the Farsi), I have been drawn to the transcendence, the spacious freedom, the alternative reality of Rumi's visionary poetry. Bahauddin's notebook comes from a different region. Plainer, less ecstatic, more practical, presumptuous, deadpan, zany. The Rumi-Shams place is an illuminated goldmine, a light shaft of revelation. Bahauddin's is more like the garden toolshed that also serves as a makeshift meditation room, very eccentric and very authentic. I love them both. Perhaps they are two versions of that fourth state of being that is in union, yet identifiable and distinct, the *individual*

soul-self, what one mystic calls a cool fire (Buddha), and another, the jewel-lights of the eyes (Bawa Muhaiyaddeen).

One aspect of the work of bringing mystical texts from the Middle Ages into the twenty-first century is finding new ways to say *God* without mentioning names. After Nietzsche's Zarathustra (God is dead) and Blake (Ol' Nobadaddy), the father figures must be replaced if there is to be transmission. The goddesses too, I'm afraid. I try various substitutions. *The presence, you, friendship, Friendship* (but aren't we dog-tired of spiritual Capitalization), *conversation, light, dark, emptiness, communion, is-ness, suchness, this whole thing, the peace that passeth* . . . etc. Nothing works. Language cannot *be* this great love. But something of it does come through. Blessed ignorant rant. This plane we live on is where nobody knows much of anything. But we can love, and even become love. We just can't hold love in words, or convey it.

I try to wean myself (unsuccessfully) away from words like *sacred* and *divine*. Being, in itself, should be, and is, enough without adjectives. Existence in the intricate particulars of any moment. As is. I love the Sufi story of the fish who school together to discuss the possible existence of the ocean, when they're swimming in it. They divide into study groups and write papers and shrug their shoulders, when it's all around them. Sufis say that's what theological speculation feels like. What we try to point to with the words *sacred* and *divine* is our very inner and outer habitat, the vitality, the cycles and the layers, even this languaging swim of drowning books.

1:2–3 There is a lot of describing mentation in these entries, attention to the *sequence* of Bahauddin's thought. As I was praying, I thought of the nymphs. . . . Which led me to

this thought. . . . The feel of one idea impinging on another. It's part of the attempt to be honest, to admit the impurities and arbitrary interruptions of his conversation with the Friend. That surely is some of what Rumi loved about his father's book. When anyone tries to say the truth, we feel the presence. We cannot ever *say* truth, but trying helps. In these conversations of Bahauddin with the divine, we feel an authentic living current of Friendship.

1:82–83 I am reminded of Augustine's prayer, Lord make me pure. But not yet (*Confessions* 8:7:17).

1:103–104 This connecting of appetites with more sublime longings is crucial to Bahauddin's fluid self. *How* the lower desiring transmutes into ecstatic love is a trade secret he does not reveal, except as the opening field of this text itself.

1:151–153 Some of what is said here is repeated in 2:115–116 and 2:145. Because of the textual situation described in John Moyne's note on The Manuscripts (p. xxxix), Book Two of the *Maarif* is bound to duplicate passages from Book One.

1:172–173 *Alif Lam Mim.* Certain chapters of the Qur'an have Arabic letters at the head of them, as Bahauddin puts them here at the beginning of this entry in a daringly bold imitation of scripture. Of the one hundred and fourteen sections of the Qur'an, twenty-nine have some sequence of Arabic letters, or sometimes a single letter, at the opening. Various theories about these letters have been put forward by scholars, but nothing definitive. N. J. Dawood says, "The fact is that no one knows what they stand for. Traditional commentators dismiss them saying, 'God alone knows what He means by these letters.'"

1:272 You are inside this always.

1:293–294 Light within a pitchdark covering.

1:295 Bahauddin stresses the importance of having a Joseph in one's life, a Shams, someone who opens the sacred mystery of being alive, of having met and then lost a great love. Bahauddin among his restless observations stays near the edge of fresh frustration.

Gary Snyder's first book of poems is called *Riprap,* after the high mountain trailstones he worked with, making footpaths in the High Sierras. One way to read the *Maarif* is to follow the *full* attention Bahauddin pays to people, ideas, verses from the Qur'an, and situations as he comes to each like the next riprap trailstone to set.

What is most wonderful about Bahauddin's text is the sense that comes through of his *individuality,* as distinguished from *personality.* We learn personal things about him, his irritation with his mother, his love of garlic, leek, and onion, etc. We also feel his deep soul identity and eccentricity. This is a precious truth of enlightenment, that the ego and personality (cultural and familial formations) dissolve, but an authentic soul-self remains and grows even more itself. This phenomenon of soulgrowth is apparent more in Bahauddin, I think, than in Rumi, because of the sidelong and oddly original vantage points.

1:316–318 The sexual vigor of Muhammad is quietly celebrated, when it is not ignored completely, in Islam. This is a clear delineation point with Christianity, and not much known about in the West. Muhammad had several wives and is said to have visited each of them every day. Each wife was tended to. The relevant hadith from the Sadih Bukhari collection in is Volume One (5:268).

Narrated Qatada: Anas bin Malik said, "The Prophet used to visit his wives in a round, during the day and the

night." I asked Anas, "Had the Prophet the strength for it?" Anas replied, "We used to say that the Prophet was given the strength of thirty men."

The details of this strand of Muhammad's *baraka* are much in dispute.

There are sexually repressed, fundamentalist elements in every religion; the Muslims certainly have their share. But we in the West have been particularly blind to this quality of Muhammad and Islam, the positive masculine dimension, the energy that loves women and enjoys sex. Other of our blindspots, qualities of Islam that we rarely acknowledge, would be the attention given to peacefulness, to friendship, to the importance and goodness of the simple worker, to craftsmanship and courtesy and faithfulness to a daily practice. I feel also that there is a quality of honoring the feminine in Islam that we do not understand. That subject, of course, is a hornets' nest. Moreso, the hadith about Muhammad's sexuality—and I have no authority or expertise to say much about either. There is a great deal of recent literature, especially that by Sufi women about women and Sufism, that I have not read. I leave this list of our blindspots incomplete and call for help, backup. *Huston . . .*

I have been warned with some seriousness *not* to include the above remarks in my Commentary. So here's a little more:

I don't know if it's true, the claim for spectacular potency in Muhammad and the men of his line. But I love that Bahauddin mentions it *as a given*. His straight talk about desire is cleansing and healing. He feels the presence of God flowing through him in that, as well as in his lyrical good humor, his humility, his surrender, his fears, his impudence, boredom, nausea, in every mood and even in illness. As the *zikr* says,

There is no reality but God. There is only God. Each blessing and each catastrophe happens within the presence. Existence itself is Allah. The whole is holy. It is a grand and complex sense of life the Sufis give us, this breathing in and out with every breath how we are, each moment, inhabiting an unnameable mystery.

The American culture I grew up in, Chattanooga, Tennessee, in the 1940s and 50s, had very little (or no) sense of the great beauties of Islamic civilization. I received a good literary education, graduate English degrees from Berkeley and Chapel Hill, but I never even heard Rumi's name until I was thirty-nine. It is clear to me now that the Farsi speakers have produced the great mystical poets on the planet: Rumi, Hafiz, Attar, Sanai. (Saadi, I confess, I am still mostly unacquainted with.) There is nothing quite like the flourishing that happened in that part of the world from the twelfth through the fifteenth centuries. We are only just now beginning to know and love the magnificent art of the great Islamic centers in Iran, Turkey, north India, Iraq, and Syria, which have endured with vitality into the present.

And something more on sex and spirit, those deeply interconnected regions and energies. It has always been hugely inflammatory to speak of, or show, Jesus as a sexual being. The same with Muhammad and his wives. Salman Rushdie is still under a threat of execution for the novel he wrote. What a nightmare that *fatwa* must have made of his life. People's feelings are easily hurt in the tender intersection of faith and sexuality. It's probably impossible to say anything on the subject without a lot of devout good folks feeling you have demeaned God's representative. Even bringing the subject up is provocative. Some would say rude. Recognizing the foolish-

ness of doing so, I continue. A writer thralled in his own wild pronouncements.

A great failure of the organized-religion part of Christianity is that whatever Jesus said or did about his sexual feelings has been almost completely expunged. We have no account of his life from age twelve to twenty-nine, generally a powerfully testosteronal time in the life of a healthy male. We're given instead the hypocrisy of abstinence, centuries of repressed priestly fumbling, and shadowy projections of sexual guilt onto others.

I do not mean to offend anyone or anyone's sense of the sacred. Please forgive me if I have or am about to. I walk some strange p.c. highwires these days. Members of the gay community have attacked me for "arrogantly" claiming that Rumi and Shams were *not* lovers in the homosexual sense— that is, that they did not engage in fellatio and anal copulation. I don't mean to provoke an argument here. Maybe I just need to acknowledge my bias. I'm not bi. And I'm not proud, or ashamed, that I'm not. It is just how my life has developed. So take this hetero-attitude with whatever salt is required. Of course I don't know for sure what Rumi and Shams did or did not do, but I don't feel like an "erotophobe" (one who fears the erotic) when I claim that the friendship they entered was beyond any synapse of touch and time, beyond teacher and disciple, beyond lover and beloved, beyond longing. They met in the heart. They became that Friendship, or love, and Rumi's poetry springs from there. That's how I hear it. My claim in this area comes out of having met one who lived at the same level of enlightenment, Bawa Muhaiyaddeen. I have no way to prove that that was his state, or even to talk about it. He once asked me, "Will you meet me on the inside or on the outside?" With English-teacherly

evasiveness I replied, "Isn't it always both?" I should have bowed and said, *Inside*.

The human heart is unassailable, relentlessly buoyant, but very weary of arguing the names and forms of the divine. I much prefer to sit with friends and talk and sing. Imagine around the table Francis, Rabia, Bahauddin, Hakim, Bodhidharma, Jesus, Augustine, Mirabai, Igjargajuk, Jalaluddin, and some strange bird from Tabriz.

1:316–318 *Mojame't,* the Persian word for sexual intercourse and potency. I had wondered if there might be a connection with the blues and jazz word *mojo,* meaning the essence of a piece of music, its life and creative core. But dictionaries say *mojo* comes from Gullah, the language spoken on the South Carolina coastal islands. It became current around the South in the 1840s and probably goes back to a West African word for *shaman.* Further back, of course, the Persian and the African sources might blend to the same stem.

1:327–329 Etheridge Knight wrote a love poem that may well have been based on a Qur'anic verse quoted here (55:19) about the two oceans:

> and I and I / must admit
> that the sea in me
> has fallen / in love
> with the sea in you[33]

1:328–329 Every taste, any faint flavor, is God. *Zikr* for the taste buds. The path of the senses is the feral streak in Ba-

[33]From "Belly Song," *The Essential Etheridge Knight* (Pittsburgh, PA: Univ. of Pittsburgh Press, 1986), p. 91.

hauddin's being, wonderfully radical and defining. When I deeply know my senses, I know in them the way to God and the purpose of living (*Maarif,* 1:10).

1:347 Bahauddin is asked what an enlightened being is. As I hear his answer, he says, Someone free of theological speculation and moral prohibitions, free of hope and fear for the future. One who is *the wine of wisdom gone mad.*

A candle has been lit inside me
for which the sun is a moth.

Much of Bahauddin's book can be read as gloss for this one entry.

1:354–355 He compares the human condition to a passed-out reveler laid in a wagon and taken he knows not whither. Human beings love, Bahauddin says, being held in the presence, carried along like the man in the wagon, who doesn't know where or how or why or when or if he will arrive wherever the wagon is headed. Satisfaction comes not with any particular answer to these questions, but with being *in the custody* of the one addressed in the *zikr* as *you: There is no reality but you, only you.*

1:364–365 His prayer at the end of this entry is *to feel more alive.* With a suggestion for God: Make me like the young woman I saw earlier today enchanting a circle of suitors. I want to be that compellingly alive. He suggests that God become as attentive to him as those young men were to her.

1:367 Listen to the soul's music and song until your Friendship with the divine revives. This is the purpose of *sama,* and of any truly mystical text.

I happened to be reading *The Intimate Merton* along with Bahauddin's notes. I love Thomas Merton, but for me the

side-by-side reading pointed up the leonine honesty of the thirteenth-century man, as opposed to the side-stepping of disclosure in the twentieth-century Merton. Listen to Bahauddin's candid listing of his wantings: My desires at the moment: I want a beautiful woman. I want wine, music, laughter. I want everyone to see the sacredness of life. I want wide recognition for myself. I want my wantings intensified, and I want to feel the divine being pouring through me every moment (*Maarif* 2:16–17). This is echoed in 2:78–79: *Make women more beautiful and my wanting of them stronger.* Other notebooks that might be read along with Bahauddin: Niffari's *Stayings (Mawaqif)*, Ruzbihan Baqli's *The Unveiling of Secrets, The Blue Cliff Record,* Whitman's *Specimen Days and Collect,* Joseph Campbell's *Sake & Satori,* Thoreau's magnificent *Journal,* which he kept from age twenty until a few months before his death, Swedenborg's *Dream Diary,* Marion Woodman's *Bone,* Gerard Manley Hopkins's *Journal (1866–1875).*

1:368–369 An uncanny story like some strange combination of Kafka and Lewis Carroll.

1:374 Bahauddin says that his self-pitying stories would dissolve if he could merge with the divine, though *self-pity* does not feel right for his tone.

1:393–394 The last point here is wonderful, how by admitting one's failures, new regions of delight open.

1:402–403 An amazing entry. I love how Bahauddin feels so immediately in himself, in the taste of bread, a vast and intricate process of nourishment and soulmaking going on between the unseen and the apparent. He sits in the doorway partaking of both. In this entry and the next (1:404) Bahauddin senses that he is part of a grand propogation that he will never understand. He can only glory in it, being very much in his body and very much in his spirit at the same

time. That is the vitality of his notebook and what attracts us to it now.

1:404 I like this educational theory, that we need many liaisons with other ways of knowing—not just other texts, but connections with actual horsetrading and carpentry, architecture and cooking. I might go back to university teaching if that sort of exchange were happening.

1:412–413 But what is depriving people of vision? He doesn't say.

2:13–14 The donkey's bray. In his poem "The Ass," D. H. Lawrence depicts the sound a donkey makes:

Hee! Hee! Ehow-ow!-ow!-ow!-aw!-aw!-aw![34]

It goes on for pages. The wonderful poem is a translation of, and commentary about, what the jack, the male donkey, laments (complaint of a dreaming Donkey Hody).

I love how Bahauddin is a master of interruptions, inviting them in, the donkeys and dogs, working all accidents into his continuous watercolor as easily as trees and flowers include weather in themselves.

2:16–17 Khotan is an oasis kingdom in Chinese Turkestan or Sinkiang, in the southern Tarim River basin. There was a migration *back* from this area to Balkh in the early days of the Common Era, so that Khotanese dialects were spoken in the area until the eleventh century.

I have read only a little on the appalling subject of this entry, the practice of female mutilation. The practice may have started in ancient Egypt, and it continues to this day

[34]From *Complete Poems* (New York: Viking, 1971), p. 380.

among Muslims, Christians, and followers of indigenous religions. It is usually an initiation ceremony for girls about twelve years old, but the reasons for it and the age at which it occurs vary greatly. The practice involves amputating some or all of the external genitalia—the clitoris, the small genital lips, and the large ones—diminishing, numbing with scar tissue, a woman's ability to experience sexual pleasure. Male control of women's sexuality is surely the basis of the practice. It is a tradition in hundreds of ethnic groups in twenty-eight countries across Africa. In the Sudan nine out of ten women have been cut. In Mali, ninety-three percent. Typically the excision is done by village women with nothing to dull the pain. Sometimes midwives apply a local anesthetic. Only very slowly is the debate about female genital mutilation moving into public arenas and courts, in Africa and elsewhere. To his credit, almost eight hundred years ago Bahauddin was horrified by the version of the practice he had heard of as "an old ceremony occurring in the Khotan region of China." The anesthetic here is wine.

2:92–93 The last section of this entry deals with the dance of the divine point, which dance we might call the mystery of center and circumference. As we begin to live from our centers, we become inexplicably loving, no matter what's transpiring through the circumferential biosphere, and profoundly grieving too, in the poignancy and beauty of the passing. This is where we die before we die, are born again, and stand at zero in the fullness of a here-now nowhere, to use the Islamic, Christian, and Buddhist-Taoist terms, respectively.

To be and not-be at once, not worrying whether 'tis nobler in the mind or the conscience. We know each other from a soul-inwardness. I asked Bawa Muhaiyaddeen once if what I saw in his eyes could ever come up and look out from behind

my eyes. He punned, When the eye (I) becomes a *We,* this will happen, as the manifold identity begins to move with the unifying core.

2:109 Rumi had one sibling, an older brother, Ala al-din, born in 1205 of Momene Khatun, Rumi's mother. Bahauddin had at least two other wives and two other children by them, though no information has come down about their lives. Rumi had two wives, one at a time. Gowher Khatun, by whom he had two sons, Sultan Valad and Ala al-din, died in 1229. With his second wife, Kerra Khatun, he had a son, Muzaffer Chelebi, and a daughter, Maleke Khatun.

2:114 If life-troubles *dry you out.* . . . I take this to mean if situations you live through reduce the charge of your current, the juicy verve of responsive awareness, then you should consider those as dangerous to your soul.

2:115–116 Different foods sing praises during the digestion process. Likewise, we are being metabolized into mystery. As we dissolve, energy gets released as gratitude. The story is told of Rumi joking on his deathbed: There is a slight earth tremor, common in the region (south-central Turkey). *Earth's stomach is growling. Quiet. You'll have your sweet morsel soon.*

In the second paragraph of this entry Bahauddin says that at the *core* of our more profound senses, of glory, surrender, and deep humility, there is a longing for a taste of love and lovemaking. Our other qualities grow from that rich combining of energy. *They spawn inside the God-pulsing delight.* It is a Blakean, Lawrencian, Bahauddinish insight, that sex is not to be denied or repressed, but acknowledged as flowing from the primal core, the source that permeates the other energies.

2:123–124 He makes a decision here to bring his work to an end, which sounds a little like Prospero in *The Tempest.* Bahauddin says, *I am God's gardener, and I want the master to be*

pleased with what I have done to show his creation in a clearer way. So I made a resolution. Then I grew weak and inarticulate. Difficulties do *present themselves.*

When Prospero gives up the outward signs of his rough magic, his staff and book, he says,

> I'll break my staff,
> Bury it certain fathoms in the earth,
> And deeper than did ever plummet sound
> I'll drown my book. (V:1:63–66)

The two statements are not similar, really. I just want to make clear the literary allusion of the title, though if I have to point it out, it's not working on any aesthetic level. Labeling depletes poetic power, like the Latin nametags on trees in the botanical garden. *Quercus alba,* white oak. The drowning of the book is the point, the tremendous move into experience and away from words, imagery, dream, mind, and imagination, or rather the mixing of all of those into a larger, more alive, unnameable soup. The ocean of existence.

I hear Bahauddin primarily as a mystic who lives within the truth he tries to say, rather than as a poet recording crafted epiphanies. But he is an artist too, a maker and master of the short prose paragraph that allows the voice to shift from the personal pronoun to the revelatory *We* without warning, without any signaling of the shift. Just because the form doesn't have a name doesn't mean it can't have a practitioner. This prose from the luminous ocean of ordinary days, sitting on the public steps, planting mint in the sideyard, talking about dreams. Prose of vision and practical jokes. I feel like I grew up in something very like his world, on a hill above the Tennessee River at a boys' preparatory school near Chattanooga.

My father was headmaster. Bahauddin would have fit right in with that eccentric bunch of matzoob faculty sitting on the bluff in the 1940s. Translation time-travel has me there with him as a fascinated seven-year-old. But that's my imagination's mind-game.

Bahauddin's notebook, and Rumi's poetry, are reminders of *experience,* larger and deeper ways we readers and listeners *might* live. The words describe a taste of grandeur and love, and as they keep telling us, you cannot do that: it's impossible to *describe* such wonders. The great winetasters may come as close as one can get. But try to tell me, really, about a pistachio, or something you have never tasted. Say what you want, eventually we *have to taste to know.*

Or think of a mystical text as a key we're given to unlock the kingdom within each person. And all around too. The *use* of the key for that purpose of release is a totally private matter. But if it is not used, the key, the poem, the notebook entry remains a museum-piece curio for scholarship, and nothing more.

2:135 Of the many flowers of knowing, which genus are you?

Bahauddin says in another place, Whenever I say the word God, a seed begins to sprout. An infinite spray of flowers opens, whose petals are the names of the beautiful human qualities: love, clarity, emptiness, and majesty.[35]

2:145 We have been given five senses to understand where and who we are. We have also been given ways of knowing the unseen, spirit and soul, their making: oneiric,

[35]Reworked from A. J. Arberry's *Aspects of Islamic Civilization, the Moslem World Depicted Through Its Literature* (Ann Arbor: University of Michigan Press, 1967), p. 255.

shamanic, poetic, musical, *sohbetian* ways. Moving through this text, we may become more familiar with various weathers of *soulknowing,* and what flows within them.

2:164 The Turk's second dream. The rope image is physically impossible, but it seems right to the psyche. The rope extends backward into the mists of infinity. Bahauddin holds the other end in the present and plaits new rope as he moves forward, the fibers materializing, growing, as he moves. Presumably, the intention and the effort to plait call new strands into being for this ultimately open-ended rope-making exercise. It's a collaboration with mystery, and the journal entries are part of it.

Here is something Bawa Muhaiyaddeen said on March 22, 1979:

> God has no form. God is a treasure without form or self-image, a treasure that can give peace and tranquillity to human life. Just as there exists a point on the tongue which perceives taste and a point of light within the eye which can see, God exists as a point in the wisdom of life, a point within faith, a power. God is a power, and that power can be seen within you.[36]

It is the great mystery, how we can become aware of and live from within that *point.* I often forget it altogether. We *do* know, though, when we're close, the taste of pure water.

Coleman Barks

[36]From *Questions of Life, Answers of Wisdom* (Philadelphia: Fellowship Press, 1987), vol. 1, pp. 31–32.

ENDPAPERS: THE FLOWERS

To paint a watercolor is to immerse in the actions of water, sun, earth, and time. I begin the process by submerging the paper in water, letting every fiber be saturated. When pigment is added, colors bleed and pool. Evaporation and convection disperse the image, pulling fuzzy ghosts into remnants of the original lines. Once dry, they are still and final. Unforeseen intersections coalesce and become intractable. There is no erasing. Absorbency is everything. When the paper is completely dry the next day, or the next, I submerge it again and add new plants, leaf or flower, in response to the existing image, stacking layers of transparency. Over time my conversation with the image resolves itself, but the watercolors are never finished, or whole. They remain continuous fragments.

Sam Seawright

Sam Seawright was born in Toccoa, Georgia, in 1959. He attended the University of Georgia and the University of Texas, and since 1986 he has had numerous exhibitions in Georgia and New York. He lives with his wife, Tara, in New York City.